GERMAN
EXPRESSIONIST PRINTS

from the collection of
RUTH AND JACOB KAINEN

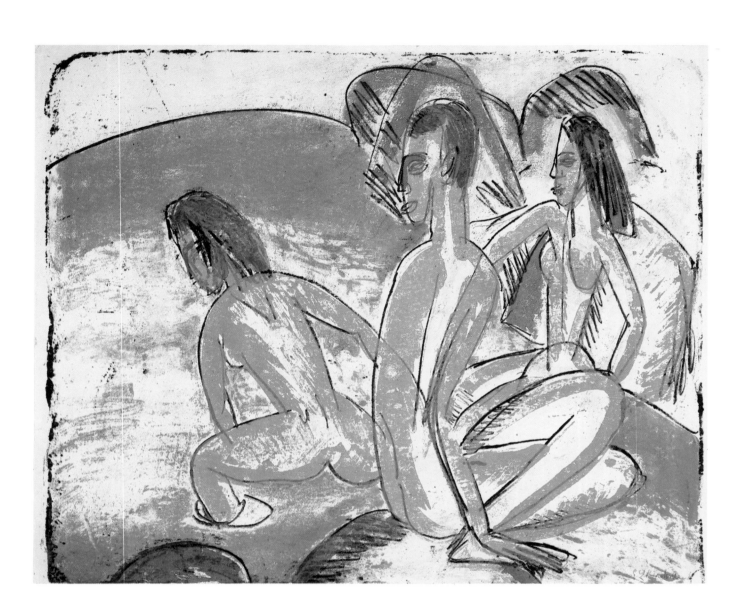

GERMAN EXPRESSIONIST PRINTS

from the collection of
RUTH AND JACOB KAINEN

organized by
ANDREW ROBISON

with essays by
JACOB KAINEN

RUTH COLE KAINEN

ANDREW ROBISON

CHRISTOPHER WITH

National Gallery of Art, Washington

This catalogue was produced by the Editors Office, National Gallery of Art, Washington. Printed by Schneidereith & Sons, Baltimore, Maryland. The text type is Trump Medieval, set by VIP Systems Inc., Alexandria, Virginia. The text paper is eighty-pound Mohawk Superfine, with matching cover. Edited by Anne Summerscale. Designed by Chris Vogel.

Exhibition dates at the National Gallery of Art:
22 September 1985 — 9 February 1986

COVER: Ernst Ludwig Kirchner, *Performer Bowing*, 1909, color lithograph (cat. no. 9)
FRONTISPIECE: Ernst Ludwig Kirchner, *Three Bathers by Stones*, 1913, color lithograph on calendered paper (cat. no. 22)

Library of Congress Cataloging-in-Publication Data
Main entry under title:

German expressionist prints from the Ruth and Jacob Kainen Collection.

 1. Prints, German—Exhibitions. 2. Expressionism (Art)—Germany—Exhibitions. 3. Prints—20th century—Germany—Exhibitions. 4. Kainen, Jacob—Art collections—Exhibitions. 5. Kainen, Ruth Cole—Art collections—Exhibitions. 6. Prints—Private collections—United States—Exhibitions. I. Robison, Andrew. II. National Gallery of Art (U.S.)
NE651.6.E9G47 1985 769.943'074'0153 85-18900
ISBN 0-89468-085-4

CONTENTS

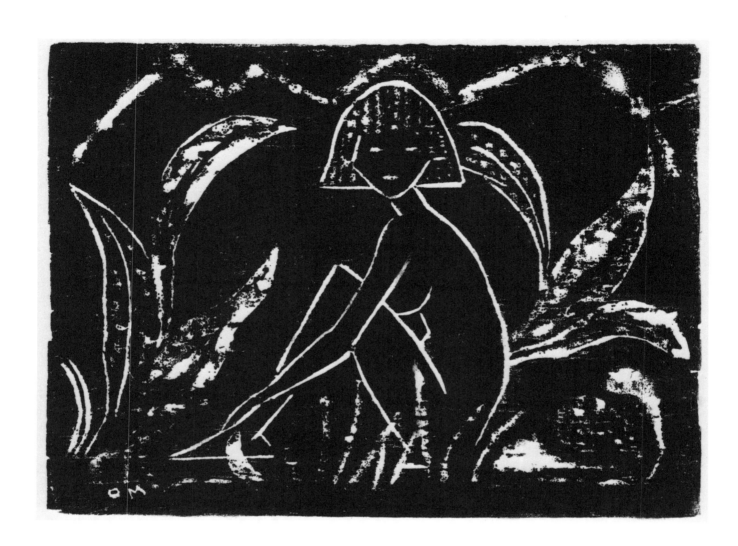

FOREWORD

THE GERMAN EXPRESSIONISTS CREATED much of the most powerful graphic art of our century. Their prints clearly bespeak the artists' intense sympathy with (or antipathy to!) their subjects, their explosive freedom in both delineation and technique, and their personal involvement through all stages of the printmaking process.

The Expressionists' humanistic art was created not merely to fulfill aesthetic manifestoes or to speak about art with other initiates but to express and communicate life to a public audience. Patrons and collections did exist in Germany, but were cut terribly short, as was the very existence of much Expressionist art, by the horror of the National Socialist regime. Many collectors and works, as well as a critical appreciation, passed to America which remains in the forefront (rejoined by Germany since the War) in the pursuit, study, and exhibition of German Expressionist art. While we have many masters still to represent in our paintings collections, the National Gallery, in particular, has a long tradition, going back to our founding years in the 1940s, of collecting and exhibiting Expressionist prints.

Among the most intelligent and enthusiastic contemporary collectors of German Expressionist prints, Ruth and Jacob Kainen have formed an outstanding group of works, and have been remarkably generous supporters of the National Gallery. The collection, only a small portion of which is in this exhibition, speaks for its own great quality and beauty, with its

opposite page: cat. no. 41. Mueller, *Girl Seated between Large Plants*, 1912, woodcut.

7

strongest weight in the best works by the finest artists. As one of Washington's foremost painters and a distinguished former museum curator and practicing scholar, Jacob Kainen brings a great historical background and a keen artist's eye to the selection of works. Ruth Kainen's infectious enthusiasm, great sense of opportunity and timing, decisiveness, and devoted search for the finest art, make her one of the most formidable collectors I have known. We deeply appreciate all that the Kainens have done for the Gallery, and thank them especially now for the loan of these ninety excellent works which show a full range of the finest in German Expressionist prints.

It is my great pleasure to announce that the Kainens have indicated all these marvelous works of art will eventually find their permanent home in the National Gallery. We will all benefit, and we deeply thank Ruth and Jacob Kainen for this latest example of generosity to the National Gallery of Art.

J. CARTER BROWN
Director

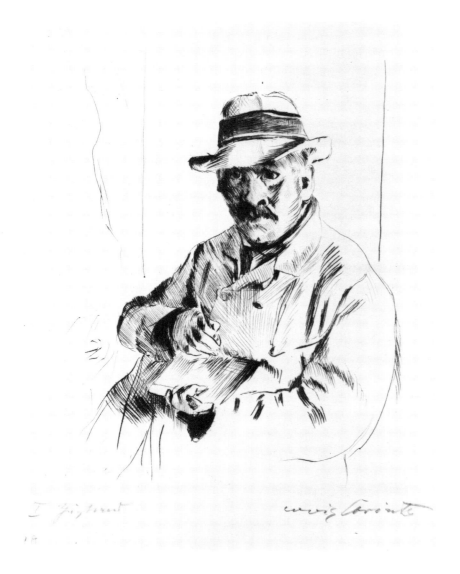

cat. no. 42. Corinth, *Self-Portrait in a Straw Hat*, 1913, drypoint.

COLLECTING TWENTIETH-CENTURY GERMAN PRINTS

Ruth Cole Kainen

Some of the prints in this exhibition were collected prior to our marriage in 1969, but at the time neither of us thought of putting together a collection of German prints and drawings. Indeed, the idea would have seemed hopeless. There was little work to be found in the United States and almost no literature about it in English. But even in Germany great quantities of German Expressionist work did not exist: the destruction that took place when the Nazis confiscated art from museums and private collections had multiplied by many times the normal losses that occur during any great war. Even in locked storage vaults art had not been safe.

Since those early days (mid-1950s to 1970), so much has been written about a "print explosion," an idea enthusiastically encouraged by publishers and print workshops, it may be difficult now to recall that as late as the mid-1960s the American market for prints was miniscule. For German print-makers and those so-called because they worked in Germany, demand was nonexistent. I remember talking with Albert Reese during a visit at Kennedy Galleries sometime in 1963 and inquiring about prints by Edvard Munch. Albert seemed surprised. "Munch? I haven't seen a Munch in years." Albert's comment was so much like one made by William Lieberman in a 1957 catalogue of an exhibition at the Museum of Modern Art that I gave up on Munch. "His prints have become increasingly rare," Lieberman wrote, ". . . the best examples are almost unprocurable." (Munch, though Norwegian by birth,

opposite page: cat. no. 23. Kirchner, *Portrait of a Girl (L's Daughter)*, 1921, lithograph on rose paper.

is generally considered a German printmaker because he lived and worked mainly in Berlin from 1892 to 1908, when he returned to Norway.)

Later, when I learned more about the vagaries of collecting, I realized the reason Munch prints were so scarce in 1963 was a simple one of supply and demand: not enough collectors had been interested in acquiring Munch to bring the work out of hiding. Until there is a good market for any artist's work, it will appear in dribs and drabs that give no clear idea of its overall character and quality. Interest in Munch began building in the late 1960s and soon after we married we found a rare woodcut at Kennedy. Within a few years the desirable images began to appear at auction with some frequency and at increasingly steep prices, which show no sign of abating. The reputations of most German printmakers, however, still suffer from sluggish demand here and abroad. Their work is not always easy to find.

I remember how, when I discovered the pleasure of prints, I searched for information to guide me. I had a book by Paul J. Sachs, *Modern Prints and Drawings*, and another, *The Expressionists*, by Carl Zigrosser but both were primarily picture books. Neither explained what constituted a good print, why one would seem fresh and interesting every time I returned to it whereas another became less compelling as time wore on. Until I obtained a copy of *About Prints* by S. W. Hayter, buying was a chancy experience. From Hayter I learned a simple, obvious rule: a good print will have print quality, unique characteristics arising from the particular graphic medium in which the work was executed and peculiar to that medium alone. German artists seem to have been instinctively aware of the importance of print quality. They experimented with the possibilities each medium offered and exploited them boldly. But print quality alone does not make a good work of art. There is another essential element that is little discussed or written about, the quality of expression. In German art it tends to be very high. It appealed to me so much that in my overall collection I had begun a small one of German prints and drawings long before I met my husband, who had been collecting them for years. The fact that Ernst Ludwig Kirchner headed the group was a bit of luck, always an important factor in collecting.

I stumbled on Kirchner's prints one frosty day in early January 1964, when I stopped by a small gallery/frame shop on Madison Avenue in New York to pick up a Matisse lithograph. There on the walls of the narrow room was a small

exhibition that appealed to me very much, though I had never heard of the artist, Ernst Ludwig Kirchner (the Germans were not mentioned in my university modern art course). I was especially drawn to an early lithograph of 1908, *Girl in a Bathtub*, but when Mr. Jansen quoted the price of $395 I hesitated. I was already in debt to him, and the thought of a running bill that never ended embarrassed me. Seeing my hesitation he apologized ruefully that "it's so expensive because it's in a very expensive frame." But when he suggested adding the $395 to my account my embarrassment vanished and I happily agreed. The expensive frame, two thick sheets of plexiglass held together with metal pins, was by no means airtight. In the late 1960s as more began to be known about conservation it became imperative to remove the print from the frame before the paper was damaged, and shortly after we married, Jacob brought the Kirchner home in a new frame. He placed it on a wall near the Matisse, and something unforeseen happened: the Matisse rather quickly began to seem less satisfactory. It was a transfer lithograph that had begun as a drawing on another piece of paper which was then transferred to a lithographic stone, but in the process the artist had made no further effort to adapt the work to the lithographic medium. It remained as it was in the beginning, a classical line drawing, but once removed from the original. Eventually we put it on another wall some distance from the Kirchner.

Jacob's background was entirely different from mine. Also, he was an artist and printmaker. Having grown up in New York, he had known about twentieth-century German artists since the mid-1930s when he regularly saw exhibitions put on by the great German art dealers then in New York—J. B. Neumann, Karl Nierendorf, and Curt Valentin—and he maintains those shows were a more important influence on members of his generation, who are commonly known as the New York School, than has yet been generally acknowledged. As a curator in the Smithsonian Graphics Division he had examined thousands of prints and drawings; he knew what made a good print. Jacob was well acquainted with print dealers all over the United States; at a time when purchasers were few, as he said, "they beat a path to my door, I had [Smithsonian] money, I bought." He had poked through boxes and storage racks all over the country and sometimes he discovered treasures. He had works by Kirchner, Mueller, Meidner, Pechstein, Heckel, Rohlfs, Schmidt-Rottluff, Gramatté, and later artists such as Willi Baumeister, Rudi Lesser, Rudi Weissauer, and Paul Heinrich Ebell, who still is not well known. And many

non-German prints as well. We both had eclectic collections. A few years after marriage, when it became necessary to make important choices between several highly desirable pieces, we were surprised and pleased to discover that our taste was basically the same. Jacob's knowledge and understanding naturally stretched my own, as did watching him make prints in the various media. On the other hand, I have not been so hampered by the ideas of accepted art history and what "fits in" or by remembering print prices in the old days, though Kirchner prices have risen so sharply in the last three years that I, too, was recently led by wishful thinking into underbidding on a highly prized early color lithograph.

In post-World War II years, New York gallery print exhibitions were confined largely to old masters and nineteenth- and twentieth-century French artists, except at Associated American Artists, but the situation began to change about the same time we married, in early 1969. Peter Deitsch, long an esteemed private dealer, went public and featured German Expressionists in a series of shows: "Important Prints and Drawings of the XIX and XX Centuries," I and II, and "German Expressionist Woodcuts," I and II, as well as solo exhibitions of Käthe Kollwitz and George Grosz. Allan Frumkin exhibited an impressive group of prints by Emil Nolde that had been assembled by Alice Adam who was in charge of his Chicago branch (Alice's sales bulletins had given prominent place to German Expressionists for some years). Dorothea Carus opened a gallery that initially was devoted exclusively to Germans; and Helen Serger began to exhibit German Expressionists at La Boetie, Inc., which had been named for a Paris street known for its French art and artists. Serge Sabarsky Gallery, which opened in 1968, initially showed the Austrians, but in 1972 it published a handsome catalogue of German Expressionists. (On the other hand, Leonard Hutton, who had been exhibiting German Expressionists since the 1960s, turned to the Russian Constructivists whose work caught on more quickly, being more in the spirit of the times.) In Washington, D. C., Harry Lunn and Jem Hom opened print galleries that featured German artists from the outset, including contemporaries. (But out in Los Angeles, Felix Landau was forced to sell all his stock of great Austrian and German Expressionist prints and drawings, and went out of business.)

In 1972 Jacob agreed to write an article on the prints of Ernst Ludwig Kirchner for publication in *ARTnews* the following year. Over a period of months we scrutinized reproductions and thought about Kirchner's work in a concentrated

way. Several of our volumes carried full-page illustrations, but even in the tiny reproductions of the Dube catalogue raisonné we could sense the power and extraordinary vitality, the remarkable print quality of the individual works. Long before the article was ready for publication, it became clear to us that Kirchner was, as Curt Valentin had once said to Jacob, "the best." As the year began in 1973 we talked over the possibility of giving up our other areas of interest temporarily to concentrate on collecting Kirchner alone and agreed this was what we wanted to do. The next day I telephoned every American dealer who was likely to have Kirchner prints in stock, and found only five examples—one in New York and two each in San Francisco and Boston. David Tunick had a small hand-colored woodcut of 1912, R. E. Lewis two large woodcuts (one of which was *Mountains with a Mountain Hut*, 1921 [cat. no. 16]), and Robert M. Light two unusually large prints, a woodcut on yellow paper and a color lithograph illustrating Zola's *La Bête Humaine*. We refused the latter two but in hindsight it

cat. no. 16. Kirchner, *Mountains with a Mountain Hut*, 1921, woodcut touched with ink.

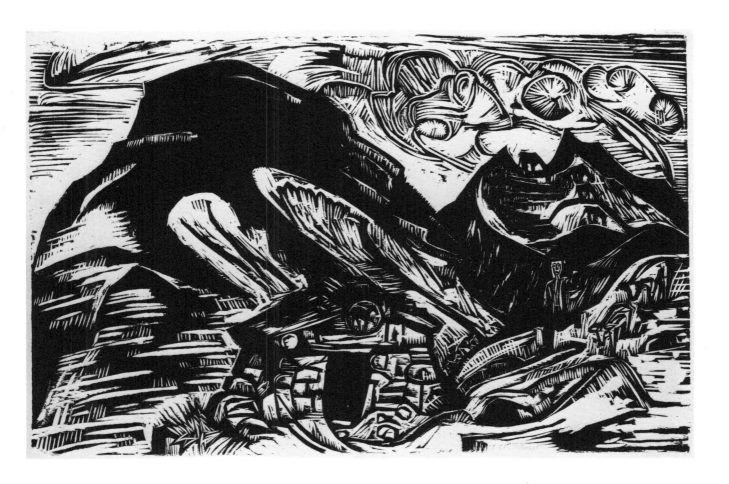

E. L. Kirchner

cat. no. 5. Kirchner, *Street Corner in Dresden*, 1909, drypoint on blotting paper.

is clear we made a mistake, especially in regard to the lithograph. At Leonard Hutton Galleries I found an exquisite, classically drawn watercolor of 1910, *Two Nudes in Landscape*; and from Boston Angus Whyte brought a large late woodcut, not what we were looking for but of such psychological intensity we could not resist it. This brought our total Kirchners to four drawings and eleven prints, not many from a body of work that amounts to more than 2100 prints and thousands of drawings.

On a quick trip to London in March, we had some luck, though the beginning was not auspicious. "There's not a German Expressionist to be had in this city!" a highly respected print dealer advised us one afternoon, but on entering the print area of Colnaghi the next day we noticed something odd: in this house known only for old masters, a German auction catalogue with a Kirchner woodcut on the cover lay on the work table as though in use. When we asked about German Expressionists the calm reply was yes, they had some, Frederick Mulder was putting together the firm's first catalogue of twentieth-century prints. Out of a drawer he pulled Noldes, Heckels, Schmidt-Rottluffs, and three Kirchners, one of which is in the exhibition. Jacob demurred about reserving the lithograph, *Portrait of a Girl (L's Daughter)*, 1921 (cat. no. 23), because there was a tiny hole in the pink paper, and I believe he was not entirely enchanted with the rather plain composition. He had long ago convinced me of the importance of acquiring the best examples in good condition, but I *wanted*

that print. Finally, I reminded him we could trade up if we found a better impression and he gave in. No other impression has appeared, and according to the Dube catalogue this is an exceptionally rare print; as can be seen, the mending was so clever the scar has disappeared. When Kirchner scholar and specialist Wolfgang Henze visited Washington recently, he explained that the two figures in the background are actually carvings on Kirchner's "Adam and Eve" chair which the artist destroyed when Hitler marched into Austria and came very near the place where Kirchner lived on the other side of the border, in Switzerland.

Remembering our agreement about collecting Kirchner only, Jacob would not let me examine the other Brücke prints, but when we returned to Washington I corresponded with Frederick Mulder, and through photographs and references identified and reserved several of them. Finally, Jacob called a halt to the exchange of letters. He thought we were acting too greedy, but what collector would not be greedy in such a situation? Colnaghi had quietly been buying German prints for some years and was offering them at prices that were exceedingly good value. Such an opportunity would never return. I was particularly pleased to find a good impression of the Schmidt-Rottluff woodcut, *Woman with Unbound Hair* (cat. no. 32). Jacob had often spoken wistfully of an impression he had owned that "looked like it was printed yesterday," and rued the fact that in an indulgent moment he had given it to one of his sons who wanted to start a collection.

Greater luck followed in 1974 when we became acquainted with the executor of the Kirchner estate, Roman Norbert Ketterer, and his wife Rosemarie. Mr. Ketterer lives in Campione d'Italia near Lugano, a three-hour train trip from Zurich. Over a year passed before he could see us, but the experience was well worth the wait. In the Ketterer world everything revolves around Kirchner. To spend the better part of a day looking through prints and drawings of astonishing quality, then conclude the afternoon in the living room of the Ketterer home, surrounded by great Kirchner and Beckmann paintings while discussing little-known information Mr. Ketterer has ferreted out about the artist is quite unforgettable. On occasion he has brought out as a special treat a Kirchner sketchbook for examination or the galleys of one of his publications such as the 1984 [Kirchner's] *Postcards and Letters to Erich Heckel*. Each postcard bears a fully worked-up composition, usually in color, as do the virtually illegible letters on yellow paper. Mr. Ketterer's contributions to the Kirchner literature are invaluable;

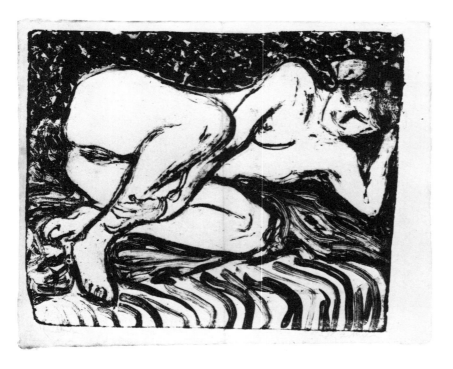

cat. no. 1. Kirchner, *Reclining Nude*,
c. 1905, lithograph.

without his tireless efforts much important information would
have been hopelessly lost.

We are indebted also to fine dealers in this country. For
instance, in February 1976, Robert Light telephoned from Bos-
ton that he would like to show us some Kirchners he had
recently "found" in Germany. Bob had been there at the same
time a catalogue listing the prints arrived in our mail. We
could hardly complain about his scooping them up when he
brought the two we coveted most: the Berlin-period woodcut
every important Kirchner collection and museum should have,
Five Tarts (cat. no. 14), and an unusually large lithograph. By
1976 Jacob himself had given up collecting: he said he did not
want to think of anything except his own work; but with these
two prints he made a kind of exception. They went into our
Joint Collection that contains pieces neither of us would want
to be without (prints in this exhibition come from three dis-
tinct collections which we sometimes refer to as His, Hers,
and Ours). We were particularly grateful when Bob wrote in
September that he had an early Kirchner woodcut of 1908,
Female Nude (cat. no. 2). We admired its bold image and there
was nothing of its character and period in our collection.

The introduction of jet airplane travel brought as great a
change in the art world as in others; at the same time a new,
mobile generation of collectors was developing. By the latter

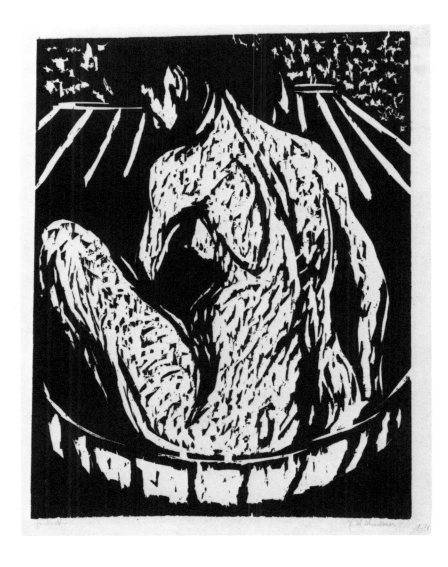

cat. no. 2. Kirchner, *Female Nude*,
1908, woodcut on blotting paper.

part of the decade the spring auctions in Germany, and es-
pecially in Switzerland, became a kind of spectator sport no
one who was "with it" dared miss. "Everyone goes to Bern,"
Ray Lewis explained, "even people who call themselves deal-
ers but do not bother with the other auctions." The sales at
Kornfeld and Klipstein, now Galerie Kornfeld, come at the end
of the spring auction round. Carefully orchestrated drama is
played out as individuals who have funds left over from the
other sales, and some who do not, find themselves bidding
wildly in the last opportunity of the season. New auction highs
are established, and widely published, when pickings are slim
elsewhere. One can't go home empty-handed! I remember the
sight in 1973 of a young woman wiping a tear from one eye
when she finally succeeded in obtaining a small Paul Klee

watercolor for $125,000, a very high price at the time. I thought she wept from joy but Jacob maintains her reaction was caused by fear of having gone too far.

In 1973, 1978, 1979, and again in 1985, auction fever combined with a certain one-upmanship and the sheer entertainment value of it all to send the print market soaring. In the years between each high point prices might fall back slightly, but would always rebound to new heights. In June of 1981, when the great Kirchner color lithograph, *Man Stepping into the Sea*, brought $135,894, thus outdistancing in cost all other nineteenth- and twentieth-century prints that had dominated the auction field, a disconsolate observation the losing bidder had made a few months earlier was fulfilled: "The fun's gone out of collecting. . . . It used to be you could go around on your own and find something [important] in an out-of-the-way place. . . . Now it's just a matter of how much you're willing

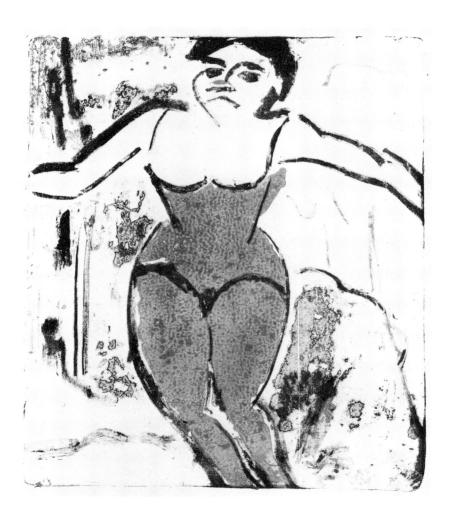

cat. no. 9. Kirchner, *Performer Bowing*, 1909, color lithograph (reproduced in color on cover).

20

to pay." Mr. Kornfeld is a scholar with an infallible sense of timing. This year (1985) when there was a dearth of good Kirchner material and no color prints, he offered a "package" consisting of letters and other documents, some pieces by Kirchner's Swiss associates and a few from the artist himself, and issued a valuable, handsomely designed catalogue that drew collectors from afar. The sale's high point was an etched self-portrait of 1916 (black and white) that brought a sum in excess of $116,000. From one side of a scraped, "scratched," and acid-splotched background the vulnerable image of the artist emerges darkly. It is a moving, tragic work and a document some believe is by way of turning Kirchner into a culture hero.

In the years since 1973 color prints by Kirchner have been for sale only at auction, but several we most hoped for never appeared, just as prints we wanted by other artists have not to our knowledge been for sale. In collecting nineteenth- and twentieth-century German prints one always has lists of most desired works, but may never see them and be forced to make substitutions. One is bounded always on one hand by what is available and on the other by funds for purchase.

When we could not attend an aution at which there was an important item we wanted, a dealer represented us, usually David Tunick or Wolfgang Wittrock. In 1979 David obtained *Performer Bowing*, 1909 (cat. no. 9), at Hauswedell and Nolte in Hamburg—and on his own, *Three Bathers by Stones*, 1913 (cat. no. 22), which we found irresistible when we saw it, and superior to a very fine impression we remembered examining at the same auction house in 1977. In 1983, Wittrock inspected and bid successfully for us on the Kirchner color woodcut of 1910, *Bathing Couple* (cat. no. 10), which is probably a unique impression, and the early Schmidt-Rottluff woodcut, *Nude* (cat. no. 38), at auction in Cologne, and in 1984 on an important Kirchner watercolor self-portrait and the Gangolf hand-colored lithograph, *Tightrope Walker* (cat. no. 87). From observation and from talking with more experienced auction-goers, primarily dealers, we had learned the importance of first-hand inspection. A catalogue photograph is not necessarily made from the print being sold, they said. On occasion a photograph from the auction house files has been substituted. Catalogue descriptions tend to gloss over less visible damage—the auction house, after all, represents the seller. Earlier this year I made a trip to New York to look at some prints being offered in two separate sales, but when I asked to see a particular print out of the frame, the director of the print department confided,

"The back is a mess!" However, "traces of discoloration and foxing" mentioned in the catalogue did not show on the framed work. It brought $1100.

There are other advantages of asking for help at auction. An obvious one is that it is easy for someone present to top a bid left with the house, not to mention those of other bidders on the spot. But perhaps more important is the fact that a dealer who constantly buys and sells is likely to be more accurate in calculating what an individual piece will bring than a collector whose relation to the market is not a continuing one.

For the person who collects a variety of artists as we do there is still another problem, the alphabetical sequence in which works are presented: one is hesitant about bidding on something that comes before the item he wants most, particularly if funds are limited. I vividly recall a lovely impression of the well-known Heckel woodcut, *The White Horses*, that went for a very low figure (for that print) at Hauswedell and Nolte in 1976. (When I mentioned the auction price recently to a German dealer, he could not believe me until we got out our marked copy of the auction catalogue.) We resisted bidding because we were waiting for two Kirchners in this exhibition, *The Blond Painter Stirner* and *Harmonica Player* (cat. nos. 18 and 17). Of course, had we bid on the Heckel, the price might have escalated; as the old saying goes, "It takes only two to make an auction." The sequence in which works of one artist are offered can also be a handicap. Unique pieces come first—paintings, watercolors, and drawings—and are then followed by prints which are presented by graphic medium and in ascending date, that is, all etchings, all lithographs, and finally all woodcuts. Because our hearts were set on Kirchner's *Russian Dancers* (cat. no. 6) at Hauswedell in 1976, we passed up a wildly beautiful 1910 watercolor of *Franzi* that still haunts me, especially since the color lithograph went for considerably less than anticipated. An early Wunderlich I had long sought brought some consolation, modified by our losing out on two very good impressions of Modersohn-Becker etchings to a wiser collector. Modersohn-Becker once worked nearby in Worpswede; her work has always been popular in Hamburg, and in Bremen a street is named for her.

Shortly after he came to the National Gallery of Art in 1973 Andrew Robison visited us. He was so enthusiastic about our German prints and drawings—in 1976 he borrowed them for a period of careful study—that I came to look forward to sharing each new acquisition with him. His appreciation seemed

cat. no. 17. Kirchner, *Harmonica Player*, 1919, color lithograph on blotting paper.

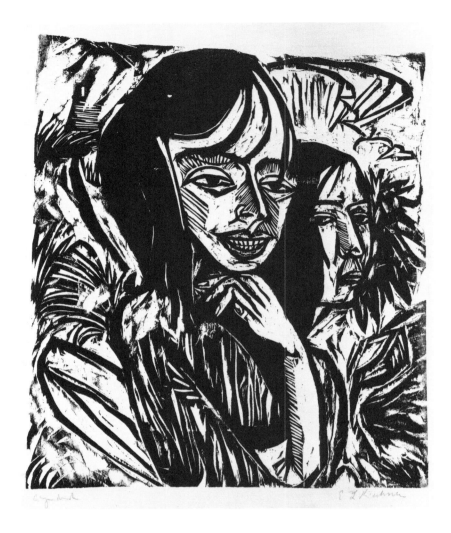

cat. no. 11. Kirchner, *Girls from Fehmarn*, 1913, woodcut on yellow paper.

to give new purpose to our endeavor and it suggested an easy solution to a problem that had come to trouble us: what was to become of the large body of material that was gathering. The logical conclusion seemed to be to designate the German works for the National Gallery and coordinate future efforts with the Department of Prints and Drawings. It is gratifying to think that our collection will eventually become part of a rich overall portrayal of modern German art that will be as important for study purposes as for display.

By the time the notion of gathering an extensive collection developed, around 1977, we had already a substantial representation of artists—some sixty-five to seventy. (The records are not complete.) Prints of little-known artists had come from widely scattered sources, often in batches. The costs were nominal if the work could be found, and also each of us was accustomed to stretching his/her individual resources for art

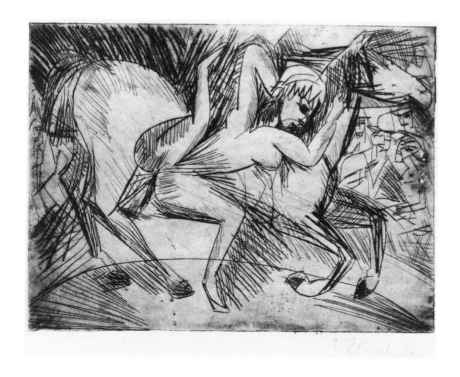

cat. no. 12. Kirchner, *Acrobat on a Horse*, 1913, drypoint on blotting paper.

somewhat further than common sense might have suggested. As Jacob often comments, "The stuff accumulates."

On trips by himself to New York in 1969 and 1970 Jacob had discovered at the long-established art gallery/art bookstore, E. Weyhe, prints that must have been in storage since Carl Zigrosser ran the print section in the 1930s. From various expeditions Jacob brought back groups of work by obscure German artists, some of which are in the exhibition (Werner Gothein, for instance). In 1970 when he came across a lithograph by René Beeh, Jacob recognized the artist's name from a 1922 woodcut by Max Unold, *In Memoriam René Beeh*. It is a particular problem to discover the work of artists who died young—Maria Uhden, René Beeh, and Paul Gangolf, for instance—and others still unknown to us.

Except for an example found in a New York bookstore bin, all the Kleinschmidts in this exhibition and others in our collection came from the collection of Erich Cohn, via his son Richard. Jacob had often spoken of a trip made to New York in the 1960s to visit Erich Cohn, who was known for having generously supported German artists during the lean years following World War I, when few people were interested in contemporary art, and still fewer in German contemporary art, and for placing the work in American museums. (The Graphics Division of the Smithsonian received a group of prints

25

as a result of Jacob's visit.) It seems likely that most of the twentieth-century German art which has been sold in this country since 1940 was brought here by German emigrants like Cohn. We were especially pleased to get a portfolio of etchings by Max Klinger, whose work we had begun to despair of finding. The problem proved to have been the one mentioned earlier—demand and supply, for a few years later when *Time* magazine ran a feature story on Klinger dozens of prints came tumbling out of collections onto the market.

Jacob has noted, incidentally, that every impression he has seen of a Kleinschmidt etching was a proof, and wonders how many editions were actually printed. It seems likely that in the 1920s and 1930s many prints by German artists never reached the stage of editions, which would be one more reason so little remains today.

In deciding to cast our net wider we were at a loss to know how to go about it. We were largely dependent on what was offered in illustrated catalogues or available in this country; but as overhead costs rose, American dealers were less and less interested in carrying inexpensive prints in inventory. (In 1980 the Walter Gramatté drypoint, *Three People in a Cabin* [cat. no. 59], cost considerably more than my Kirchner in 1964.) It was difficult to acquire work by the less-known artists in

cat. no. 4. Kirchner, *Windmill near Burg on Fehmarn*, 1908, lithograph on japan paper.

cat. no. 19. Kirchner, *Mountains*, 1920, etching and tonal etching, touched with ink, on blotting paper.

foreign auctions because it was seldom illustrated in catalogues. Without knowledge of an artist's work and images, one was virtually helpless. We began a more concerted effort to build a reference library, but finding the books, most of which were long out of print, has proved to be almost as difficult as finding the art. As the library grows so does the collection.

In 1977 I noticed a tiny advertisement that ran only once in the *New York Times*: "Forgotten German Printmakers, Third Exhibition, Martin Sumers Graphics." Displayed at Sumers I found work by artists I had never hoped to see in this country, and in the years since 1977 we have appreciably added to the names of "unknowns" in our collection. In 1979 we were pleased to find at Sumers examples of two unusual late nineteenth-century printmakers unknown to us, Osmar Schindler

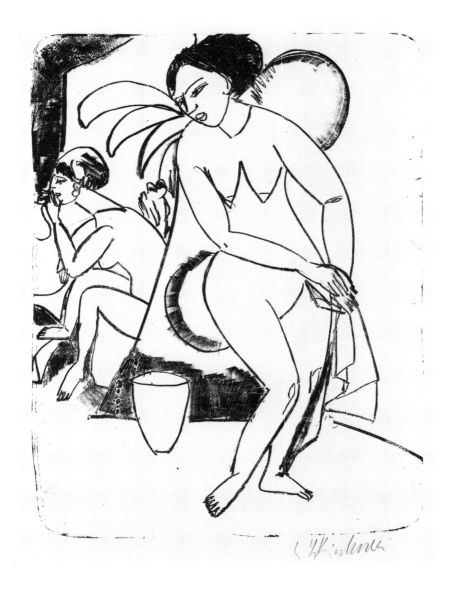

cat. no. 8. Kirchner, *Naked Girls in the Studio*, 1911, lithograph.

and Felix Hollenberg. These, with nineteenth-century prints we already had, including examples by Franz von Stuck and Arthur Illies among others, provide a base of reference from which to consider the radical changes that took place in German art after the beginning of this century.

In searching together for good German prints we had also acquired moderns: Wunderlich, Meckseper (those who know current prices will be pained to read that our first impression from Sotheby-Parke Bernet cost $85), Hans Erhardt, Max Ackermann, Horst Antes, and especially Willi Gafgen. Jacob first found a Gafgen color intaglio at Franz Bader in Washington, but could not decipher the signature and the dealer could not

remember it. Jacob speculated that "it looks a little like Wunderlich," but was unable to solve the mystery until he came upon a later print with a legible signature at the Mickelson Gallery, also in Washington. (Gafgen had been here and probably left both prints at the same time.) During the summer of 1976 we were repeatedly surprised to notice in Paris a distinctly German influence on the printmakers working there; when Jacob mentioned it to Jacques Frélaut, the famous printer, he explained that Gafgen was working in Paris. We should have known, as Jacob had been buying Gafgen regularly from the French publisher and gallery owner, F. S. Paul-Cavallier, on his periodic trips to the United States. More recently we have added Marcus Lupertz and A. R. Penck who we believe has a special feeling for graphic media.

As discussed earlier, when a relatively unknown work brings an unexpectedly high figure, other impressions by the artist begin to appear. So it was with the Gangolf *Tightrope Walker* (cat. no. 87). This year four more Gangolfs were offered in the Cologne auction, and again we bid, acquiring two. We begin to hope that a chain reaction may be set up that will one day bring forth an impression of that remarkable Gangolf lithograph, *Saint Anthony in Torment*. But where, I wonder, are the 1894 etchings of the Hamburg harbor by Leopold von Kalckreuth? They must have influenced Nolde's etchings of the same subject and would be an important addition to our collection. What could be done to bring to light a 1920 woodcut by Martha Schrag? And *Reclining Nude*, the rare color woodcut by Heckel, where is it? Are there other German artists as yet unknown whose work is as compelling as Gramatté's? It seems possible. But where can they be and how can one seek them out? It could be an unending search.

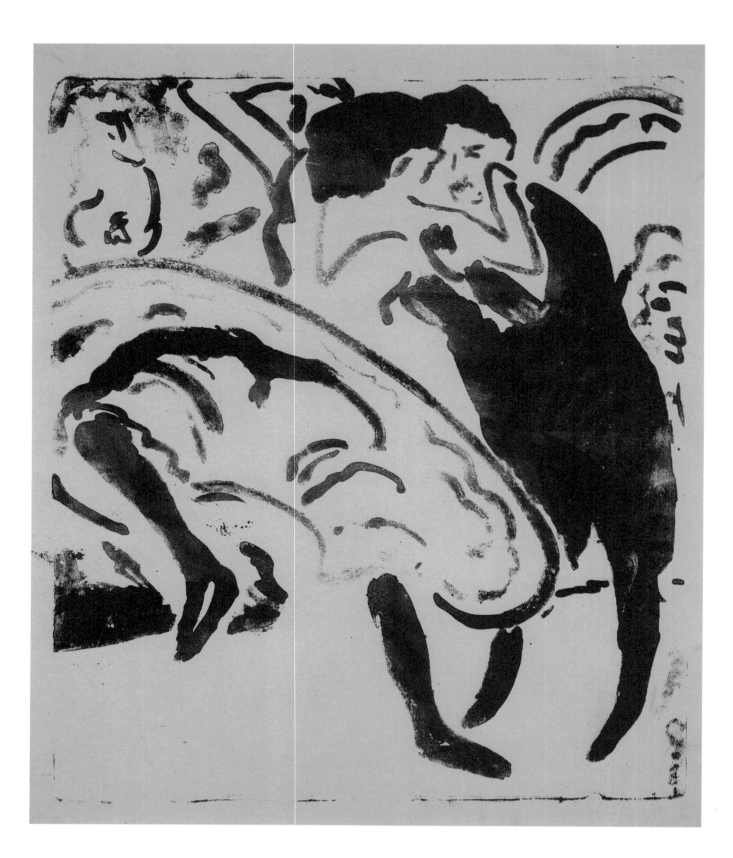

SECTION 1

E. L. KIRCHNER AS A PRINTMAKER

Jacob Kainen

However one ranks European artists of this century, Ernst Ludwig Kirchner belongs with the top few.[1] Certainly he was the most monumental of the Germans. Breaking with naturalistic impressionism as represented by the vigorous non-chromatic brushwork of older countrymen such as Max Liebermann, Max Slevogt, and Lovis Corinth, he became the pivotal German modern in the twentieth-century sense by leading the daring Brücke group over a period of years, beginning with 1905, in the practice of treating the picture surface as a more or less flattened unit having its own decorative logic. This practice was much more revolutionary in Germany than in France, where the Fauves could enlarge on the precedents of Gauguin and the neo-impressionists.

But modernity for Kirchner and his generation meant more than the allurements of color and pattern; it included the healthy excitements of imaginative youth together with a strong sympathy for those at the bottom of the social ladder. These were some of the ingredients of Expressionism, and in many ways Kirchner was the archetypal German Expressionist: in his art as in his private life he defied prevailing standards; he came to grips with his experiences in a sometimes shockingly direct manner; he was a graphic artist par excellence; 639 of his paintings, drawings, prints, and sculptures were confiscated from public collections by the Nazis; he was included prominently in the Degenerate Art exhibit in Munich in 1937; and in 1938 he committed the final Expressionist act of suicide. But he was also atypical: social protest, pathos, or harrowing

opposite page: cat. no. 3. Kirchner, *Dancing Couple*, 1909, lithograph on yellow paper.

31

subject matter rarely appears in his art, and from 1917 on most of his life was spent in virtual seclusion in the Swiss Alps, far from the big-city environment implied by the Expressionist ethos. He had well-developed theories of color and pictorial structure and was interested in the intellectual aspects of art in general. At the same time he was the most Gothic of the Germans in his expressive angularities and his treatment of the picture plane as a field in which various actions and objects were sometimes illogically or nonchronologically related, as foreshadowed, for example, by Dürer's woodcut illustrations for the *Apocalypse*.

Kirchner's monumentality is most evident in his print-making. In this art he was far more exploratory—and over a longer period—than any of his contemporaries, much more involved with color and much more productive. The Dubes have catalogued about 2,150 of his known prints,[2] a stupendous body of work unmatched by that of any other Western print-maker, including Picasso, who outlived Kirchner by thirty-four years.[3] It is awesome (no other word seems suitable) to consider that Kirchner alone, without professional assistance, prepared, executed, and printed virtually all of his prints, many in a full range of colors. Perhaps only a printmaker or printer can appreciate fully the magnitude of such an effort. Kirchner was moreover one of the most prolific painters of his time, a major book illustrator, and a consistently productive sculptor.[4]

We are dealing with one of the great workhorses of art history—only Picasso in this century had the same superhuman dedication. One cannot avoid an immoderate tone in speaking about him, particularly since Kirchner achieved what he did against some severe restrictions. He was at any rate a compulsive image-maker. As a printmaker his phenomenal productivity and graphic intensity set him apart from his contemporaries. I don't say emotional intensity—Munch, Rohlfs, Rouault, Nolde, Beckmann, Dix, Grosz, Corinth, Meidner, and Kollwitz, among others, could be as troubling. But Kirchner's prints as graphic products generate more excitement, they go deeper into each medium's latent potential. I cannot think of another twentieth-century printmaker, not even Munch or Nolde, who consistently gives off quite so strong a smell of graphic flesh and blood. Perhaps Kirchner's father had something to do with his son's bewitchment with making printed images. The father had been a chemist in a paper mill in Aschaffenburg, where Ernst Ludwig was born 6 May 1880, but moved his family to Chemnitz ten years later to become professor of Paper Technology at the Technical College. When

his son was fifteen, Professor Kirchner taught him to make woodcuts. Probably such early initiation into the mysteries of paper, inks, and other graphic materials awoke in the young Ernst a strong feeling for the physical properties and potential of printmaking.

Modern German art, and modernist printmaking in Europe as well, begins with Die Brücke (The Bridge), the artists' organization founded in Dresden in 1905. The four original members, Kirchner, Erich Heckel, Karl Schmidt-Rottluff, and Fritz Bleyl, were all students of architecture as well as aspiring artists whose real desire was to turn German art in a radical new direction. The group was strengthened in 1906 by the addition of Emil Nolde and Max Pechstein; Otto Mueller became a member in 1910. Members of the group placed prints on an equal level with their paintings. In both fields they refused to settle for accepted procedures; the technical liberties they took were unprecedented. By the end of 1909, Kirchner, Heckel, Schmidt-Rottluff, Nolde, and Pechstein had behind them a large body of the finest and boldest prints in Europe. Kirchner alone had by then turned out about 380 prints. During the same period in France, by comparison, Picasso had made only a few small prints in addition to the Blue Period *Saltimbanques Suite* of fifteen intaglios which were not published until 1913. The Fauves had produced few prints and Jacques Villon had hardly developed beyond his turn-of-the-century outlook. The real printmaking drive in the modern sense, therefore, came from the Germans, who took the aesthetic lead in Europe for the first time since the Renaissance.

In their essential motivation Brücke members differed from the French. The Germans were more idealistic; they gave themselves inspirational jolts through group readings from such antibourgeois writers as Nietzsche and Whitman. When they drew and painted unposed nude figures in leafy Edens, they were at the same time creating symbolic images in defiance of stultified Wilhelmian morality. Kirchner was a leader in the Brücke's pursuit of a freethinking way of life. In the all-embracing fashion of his favorite poet, Walt Whitman, he made many hundreds of sketches on summer vacations with his future wife Erna Schilling and other liberated women, sometimes in the company of Heckel, Pechstein, and their friends. These swiftly made drawings at the Moritzburg Lakes or Fehmarn on the Baltic became an inexhaustible source for later prints and paintings.

Kirchner outlined his own aims in a letter to Curt Valentin in 1937:

Did you know that as far back as 1900 I had the audacious idea of renewing German art? Indeed I did, and the impulse came to me while looking at an exhibition of the Munich Secession in Munich. Their pictures were dull both in design and execution, the subjects uninteresting, and it was quite obvious that the public was bored. Indoors hung these anaemic, bloodless, lifeless studio daubs and outside life, noisy and colorful, pulsated in the sun.

Why didn't the good Secessionists paint this full-blooded life? The answer is that they could not because they did not see it. It was outside and it changed incessantly, and when they dragged it into their studios it ceased to be life and was merely a pose. . . . I arrived in Dresden and during my studies was able to arouse my friends' enthusiasm over my new ideas.[5]

Kirchner's work took into account the primitive and non-European cultures that began to affect European art decisively in the first decade of the twentieth century. Japanese woodcuts and Gauguin's Polynesian forms had shown the way, and the more searching artists came to recognize that inspiration could come from aesthetic values distant from the European tradition. Picasso, Matisse, Derain, and others in France and Brücke members in Germany began to scrutinize the arts of Africa, Melanesia, Egypt, India, and Mexico, as well as earlier European arts such as the Etruscan and the Pompeiian.

But German and French artists reacted differently to primitive arts. With their heritage of Teutonic folk mysticism and greater concern with subjective expression, the Germans were less concerned than the French with the professional niceties of picture-making. They knew that directness of expression, even when it was attended by a certain rudeness and naiveté, accounted in large part for the appeal of the primitives. The Germans were ready and willing to discard many of their European cultural reflexes. In comparison, Picasso and Matisse, even when influenced by primitive sources, drew like classical draftsmen in the tradition of Raphael and Ingres.

The idea of starting from the beginning carried over into printmaking, which had built-in traditions and rules of quality. These traditions stemmed from their longstanding function—to translate paintings, drawings, and other existing objects into printed pictures for a mass audience. Artists had long resisted strict rules of craftsmanship, which were based largely upon exactness of rendering and efficiency of printing, but few had carried defiance to extremes as a matter of principle. (Gauguin, a few years earlier in France, is one of those few.) By flouting professional standards on a large scale, the Brücke artists opened

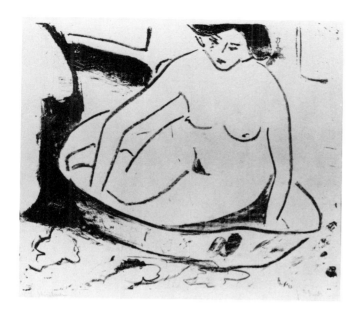

the way for new conceptions in the graphic media.

A total disregard for practical issues played a part in the Expressionist rejection of traditional printing. Good professional craftsmen as a matter of course (and a matter of commercial necessity) were required to make all impressions in an edition as identical as possible. But Brücke members felt no need to print in this way. They had no responsibilities to publishers, only to themselves; they could risk failure, they could vary inks, papers, and techniques as they pleased. On the occasions (rare before 1912) when they employed professionals they chose men who would follow their directions—Felsing for etchings and Voigt for woodcuts, for example—and produce results not too distant from their own. Regardless of their own preconceptions, these flexible master printers tried to do what the artists wanted.

All members of the Brücke emphasized a lusty attack but Kirchner had the strongest and most varied command of composition. He could produce the effect of deep perspective in the woodcut *Female Nude*, 1908 (cat. no. 2), and turn the perspective lines into a flattened radiating pattern, or he could use rhythmical brushstrokes in broadly reciprocal movements in the lithograph *Dancing Couple*, 1909 (cat. no. 3). Though Kirchner was by this time part of the advance guard in Europe he was so secure in his own ideas that any slight influences he might have absorbed were part of the general *zeitgeist*. Matisse's gliding classical line is suggested in the lithograph *Girl in Bathtub*, 1909 (fig. 1), but Kirchner's line is both more succinct and more tender than that of Matisse.

fig. 1. Kirchner, *Girl in a Bathtub*, 1909, lithograph.
Photo: © Dr. Wolfgang and Ingeborg Henze, Campione d'Italia.

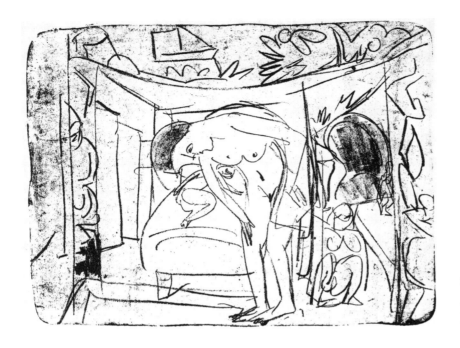

fig. 2. Kirchner, *Nude Drying Herself before the Bed*, 1912, lithograph. Photo: courtesy of the Division of Graphic Arts, Smithsonian Institution.

Cubist methodology had no attraction for Kirchner. It did little more for him than reinforce the sense of formal organization he had already absorbed from the old masters, Dürer in particular. Cubism, after all, can be seen in part as a telescoping and stereoscoping of structural principles inherited from earlier masters such as Dürer, Bellini, Titian, and Poussin, and reasserted in the late nineteenth century by Cézanne. This outlook related naturally to the flattened perspective of Gothic woodcuts that had been a strong source of inspiration to most Brücke members.

Kirchner made many important prints before 1909, but in that year his first major style was formed. It was based upon his conception of drawing, which he likened to "hieroglyphs of nature," that is, drawing so swift and summary that natural forms were reduced to their graphic equivalents. It was his way of capturing life's intangible immediacy. Kirchner tried to grasp what the Secessionists had missed, as he wrote to Curt Valentin:

> First of all I had to try to find a method whereby I could seize the effect of motion; here I was helped by the Rembrandt drawings in the Munich Kupferstichkabinett. They taught me how to arrest a movement in a few bold lines. I practiced this wherever I went. At home and elsewhere I made larger drawings from memory, catching the passing moment and finding new forms in the swift ecstasy of this work, which, without being true to nature, expressed everything I wanted to express in a bigger and clearer way.[6]

fig. 3. Kirchner, *Headwaiter in Café*, 1904, color woodcut. Photo: © Dr. Wolfgang and Ingeborg Henze, Campione d'Italia.

The sketches were not simply studies from nature, they were also compositions of lines, shapes, and movements. In his studio he used them to make larger, more fully organized drawings, watercolors, and pastels that were the basis for prints and paintings. Many of the drawings and prints dating back to 1909 are in the nature of inspired scribbles. (About twenty years ago I showed Kirchner's lithograph *Nude Drying Herself before the Bed*, 1912 [fig. 2], to the art critic Jorge Romero Brest; he pointed to the scribbled lines and said, "Forty years before Picasso.") Kirchner's drawings can never be mistaken for those of anyone else; he belongs among the great draftsmen.

Since Kirchner was brought up with the woodcut, it was natural that his first mature prints were in that medium. Early examples are caricatures in the *Simplicissimus* manner followed quickly by more developed art nouveau images reminiscent of the poster style of William Nicholson and the more exotic patterning of Félix Vallotton. When Schiefler began to catalogue the prints in 1918, however, Kirchner had second thoughts about what he wanted to preserve. Annemarie Dube-Heynig says: "The catalogue made by Gustav Schiefler contains only a few of the best examples from the years 1904 and 1905. Kirchner himself had looked through these prints and discarded a large number."[7]

From the beginning he was predisposed to conceiving his woodcuts in terms of pattern and silhouette, as in the small brilliantly colored *Headwaiter in Café*, 1904 (fig. 3). The breadth of treatment demanded by the block print undoubtedly influenced Kirchner's outlook as a painter—the quick parallel strokes of the gouge were repeated by the nervous strokes of brush and pigment on canvas. Throughout his life the artist continually returned to the uncompromising gouge and knife to stabilize his thinking, and he returned often enough to produce almost one thousand woodcuts.

In Kirchner's hands the medium reached a high point of flexibility. At times he used a hard, dense wood such as maple; it demanded unusual labor but could hold shallow tonal inflections made by the chisel, as in *The Wife of Professor Goldstein*, 1916 (cat. no. 15). Early Brücke woodcuts by Schmidt-Rottluff and Heckel sometimes were similarly nuanced. But Kirchner used another technique on a variety of firm-surfaced planks that was rarely attempted by others. In this method the V-shaped gouge was used like the burin in wood engraving. The difference was that the graving tool was much more difficult to control against a plank grain, and that Kirchner drove the tool forward loosely and without much deliberation. In

cat. no. 15. Kirchner, *The Wife of Professor Goldstein*, 1916, woodcut on blotting paper.

cat. no. 18. Kirchner, *The Blond Painter Stirner*, 1919, color woodcut on oriental paper.

this way he produced flurries of "white lines" (the unprinted paper) that modeled forms on the inked background. Among the great prints he made by this method were *Head of Ludwig Schames*, 1918, and *The Blond Painter Stirner*, 1919 (cat. no. 18), the latter a large work in color. Stirner looks at the viewer with quiet resignation in pale blue eyes that are set in a red-brown face. A down-curving sickle moon carries the curve of his head upward; a cat is imprinted on his neck. He is flanked by two primitive nudes. The background is deep violet. To obtain good register for this print (for which several trial efforts exist in other color combinations) Kirchner sawed Stirner's face and neck out of the block with a jigsaw, inked both blocks, and reassembled them for printing. The sawing technique, adapted from Munch's adaptation from Gauguin, was used occasionally by Kirchner and Heckel.[8]

Kirchner's search for original formal qualities never submerged his desire to interpret everyday life. He could modify the shapes and colors of nature and still remain true to nature's essential content. This double concern made him a great portraitist while retaining his modernist credentials. Perhaps only Munch rivaled him in this area, but the Norwegian was seventeen years older than the German and represented a more traditional, less capricious approach to portraiture. Furthermore, Kirchner overwhelmed the graphic field with his hundreds of portraits in all media.

Comparing his woodcuts with those of Munch and Nolde, who more often used the softer white pine, we can see that Kirchner's were crisper and had a wider range of tonal modulation. Sometimes we can see the fine grain of the wood pressed deeply into the darks, suggesting the crunching pressure of an etching press (this quality does not show in reproduction). Kirchner's technical waywardness was the result of his drive to go beyond what he knew. The Dubes, for example, describe six different techniques used in making the color woodcuts and it is certain that other, less ascertainable methods were applied in all media.[9]

Kirchner's first lithographs were drawn in 1907 and printed by Römmler and Jonas in Dresden. Fine as the impressions were, the artist felt that the division of labor between the printer and himself was restrictive, that it locked him into technical orthodoxy to an unacceptable degree. Kirchner was never meant to work with an artisan. And so he began to print his own lithographs and to develop unique if not industrially reliable methods of processing.

The prospect of drawing on the stone and then merely

printing it no doubt struck him as a reproductive rather than a creative approach. The chemistry of lithography is extraordinarily flexible and Kirchner set out to exploit its possibilities for his unique ends. To explain a complex procedure in simplified terms, he drew on the stone, covered his drawing with a film of water to which some turpentine was added, and fanned the mixture dry. The crayon lines and tones bled a little, turning into fused lines and mottled surfaces. The image was then etched; the faint oily turpentine residue resisted the acid slightly in patches. When rolled up with ink, the crayon lines turned into another kind of marking, one better suited to the artist's deliberately rude style. Also, by under-etching the stone on occasion, he permitted a heavier charge of ink than the drawing called for and ensured the image's gradual, or not so gradual obliteration by the engulfing ink. Kirchner's lithographs are always marked with the uneven edges of the stone, another practice professional workshops would find both hazardous and impractical.

The "turpentine etching" was sometimes carried to extreme lengths. There are prints in which the lines are so blurred they hardly show through a dense morass of ink. Figures, interiors, and landscapes loom cloudily through a speckled mist. Yet these technical "defects" are for the most part intentional, expressing as it were the hoarseness of passion. The vitality of the images is such that the splotchiness is felt more as an excess of ardor than as the result of botched printing.

Of all his prints, the color lithographs seem the most allied to his drawings and paintings. Technical unorthodoxy could hardly go further. As Heckel explained, he and Kirchner were forced to contrive methods of color printing because, in the beginning, they had only a single stone, and with this stone they resorted to methods that would horrify professional craftsmen.[10] Kirchner continued to use those methods, among others, throughout his life. His *Russian Dancers* of 1909 (cat. no. 6), for example, shows the kind of infinite variation he could achieve through a rhythmical black outline, lightened and blurred by acid in critical spots, and three loosely superimposed colors that in their nervous application create a feeling of forms in movement. The color areas themselves have a curiously mottled, flecked quality that is unique with Kirchner.

The etchings and drypoints appear even less "professional" than the lithographs in their execution and printing. They have a disarming, sometimes dismaying roughness and scratchiness that includes apparently accidental acid spots, smudges, and inky edges. The drypoint *Bridge on Crown Prince Embank-*

ment, 1909 (cat. no. 7), is reproduced here in the second state, with numerous acid spots, as described in Dube. Yet the first state, the state Dube reproduces, is the same image but entirely free of spots. Kirchner, then, deliberately put acid smudges on his drypoint plate in the second state to give the river scene life and nuance. At other times the tonal effects were accidental, the result of Kirchner's habitual practice of working on both sides of his plates.

The defiance of traditional procedures often went to self-destructive lengths, as in his occasional use of a hard, coated paper, impossible to dampen properly, for printing drypoints and echings. Drypoint subjects in particular were quickly damaged; blurred trails of ink show scars made by ridges of burr. White specks sometimes appear in etchings where the stiff paper was not pressed deeply enough into the sunken lines to draw out the ink. A faint disquiet comes from the mauled images. What Kirchner evidently wanted was a feeling of the willfully handmade; what he wanted to avoid was the smug look of an expertly produced edition print. Yet the intaglios on coated paper very often exhibit a beautifully nuanced, satiny sheen unobtainable on other surfaces.

The artist's usual practice was to print few impressions in any medium. Estimates of the number vary but at most they ranged from six to ten examples except for publications of the Brücke and for a few commissioned editions. In effect, Kirchner worked on a block, plate, or stone, making trial proofs as

he went along until he was satisfied with the image, then pulled a few prints which he never numbered (as an edition impression) and often failed to sign. Many prints have numerous states, and it is likely that we know some only in a single state because previous or later states have not been found. Prints never seen before, except in the small reproductions of the Dube catalogue, appear constantly on the market. We have the impression of a vast number of powerful images that shift kaleidoscopically without stopping long enough for comparison to be made with other examples of the same image. The great color prints among the lithographs—*Russian Danc-*

ers, 1909 (cat. no. 6); *Dodo with Japanese Parasol*, 1909; *Tart in Feathered Hat*, 1910; *Man Stepping into the Sea*, 1913; *Three Bathers by Stones*, 1913 (cat. no. 23); *The Tramway Arch*, 1915—and among the woodcuts *Moonlit Night in Winter*, 1919; *Weatherbeaten Fir Trees*, 1919; and the two portraits of Otto Mueller, 1915—among numerous others, although rare and therefore not generally known, are now extremely desirable to collectors and qualify as art-historical icons.

The Brücke disbanded in 1913. Kirchner continued printmaking at his old pace although new, disillusioning ideas permeated society; the old Brücke idealism seemed hopelessly Utopian. He was a lonely, impoverished man in a large city when his great Berlin period began. Buildings, cars, pedestrians, and other urban phenomena were treated in jagged patterns resting upon diagonal, rhomboidal, and circular movements and countermovements. A Gothic flatness prevailed. In the woodcut *Five Tarts*, 1914 (cat. no. 14), one of the more memorable Berlin images, the spiky heels and feathered hats of the prostitutes add to the general agitation. During these years (1913-1914), Kirchner produced about 130 paintings and 100 prints. The number of paintings was average for such an unbroken period of work; the number of prints was below average, but not to an appreciable degree.

The Berlin period marked an important new development in Kirchner's art and was a high point in German Expressionism. It was cut off abruptly when the artist was drafted into the Field Artillery in Halle early in 1915. Army life went against his grain; he suffered a complete breakdown and was given a leave of absence until the autumn to recover his strength. Early in December he was released from military service on the recommendation of his commanding officer, Professor Hans Fehr, a former supporting member of the Brücke. On 7 December Kirchner wrote to his friend and patron Karl Ernst Osthaus: "I have just been released from the army and will go to a sanatorium to regain my health. I feel half-dead from mental and physical pains, I can only work at night now."[11] Despite the difficult months in the army, he was able in that year to complete 25 paintings, 24 woodcuts (including the great color plates for Chamisso's Peter Schlemihl), 13 etchings, 44 lithographs, and at least 3 pieces of sculpture.[12]

During the next few years he was in and out of sanatoriums, shaken by physical and nervous disorders and by the alcohol and narcotics taken as painkillers. Nevertheless, he continued working at his self-destructive pace which, it seems, was essential to his survival as an artist.

cat. no. 14. Kirchner, *Five Tarts*, 1914, woodcut on blotting paper.

Kirchner had always feared he would be recalled to military duty but in the spring of 1917 his health was so precarious that he was given official sanction to move from Germany to Davos, Switzerland. Aside from his other problems, he suffered from lameness of the hands and feet, a condition that would recur from time to time. His wife Erna was given the legal right to sign his name, and his signature often appears in her handwriting on prints of the period. He was also unable to write letters, a hardship for Kirchner, who probably had the most voluminous correspondence, as well as other writings, of any significant artist in this century. However, his inability to write does not seem to have seriously affected his production of drawings, paintings, prints, and sculpture.

In the Swiss Alps he found himself confronted with new

44

subjects—overwhelming mountain landscapes, peasants, quiet villages, and farm animals, a wrenching contrast with Berlin and big-city life. It took Kirchner some time to become accustomed to what amounted to a second life in entirely new topographical and cultural surroundings, especially as a man with little money and ruined health. Woodcut portraits were his bridge from one world to another. Among his earliest in Switzerland were two made in 1918 of Henry van de Velde, one light against dark and the other dark against a turbulent lightness. Annemarie Dube-Heynig notes that Kirchner, in his own pair of these woodcuts, had written "Van de Velde, the Architect" under the first and "Van de Velde, the Man" under the second. She gives Kirchner's comments about these prints in his letter to Gustav Schiefler dated 21 August 1918:

> The woodcuts were from last summer and unfortunately I cannot make any more now. They were printed here in the sanatorium in Kreutzlingen with the help of my nurse. The world of the mountains has so changed me that I have to start again from the beginning. Writing and drawing are too unclear and confused, but the knife, held in both hands, enables me to make more or less of a steady stroke, although some of the planes become too disintegrated owing to my fatigue. In this pure world I must try to build a new arch for *The Bridge* if I may apply that expression to your writing on my work.[13]

Kirchner was usually optimistic but during the low period of 1917-1918 was much concerned with his mortality. The woodcut *Head of a Sick Man, Self-Portrait*, 1917, both in black and white and in its unique monotyped version in color, shows the artist as a deaf-mute gesticulating with his fingers. And in the *Self-Portrait with Dancing Death*, 1919, the artist shows his exploding head with a dancing skeleton constituting his body, the death's head in his brain.

His mood changed as he adapted to his quieter way of life. The great panoramas were particularly suited to large woodcuts. Aside from those already mentioned are various views of the Stafelalp, such as *Mountains with a Mountain Hut*, 1921 (cat. no. 16), with its contorted cloud forms echoing the mountain's curves. Among the great woodcut portraits not already mentioned are *Father Mueller*, 1918 (a monotyped impression in color is in the Museum of Modern Art, New York), and the intense *Head of Hodler*, 1918, in red and blue, with landscape and male and female nudes in the background. Kirchner's health improved in the clear alpine air to such a degree that he would occasionally visit his old haunts in Germany. The production of etchings increased; his later intaglio

work is among his best. There were some long unbroken periods of intense activity but relapses were more than occasional.

About 1921 Kirchner began to adopt a folkish directness springing from his association with simple mountain people. He had always appreciated the virtues of unsophisticated toilers and now saw their very commonplaceness as the source for a new, untapped modernism, a contemporary kind of primitivism. The prints differed from those of Rohlfs, Nolde, and others inspired by folk traditions in that they were more expressive of everyday life and also more highly organized as formal units.

From about 1922 to 1927 Kirchner made designs for the weaver Lisa Gujer to execute. In this Tapestry Period in Wildboden near Davos he developed a calm, patterned form of Expressionism unique in European art. Subject matter seemed beside the point, the emphasis was on painting as such, much as in the best contemporary work by artists such as Matisse and Braque. What placed Kirchner's work in the Expressionist category, despite its stunning decorativeness, was the sentient quality of the figures making up the ensembles. The prints of this time repeated some of the Tapestry themes but more often were inventive variations of mountain subjects, nudes in landscapes and interiors, and peasant genre. Allegorical implications became stronger, as in the etching *The Wanderer*, 1922, based upon his well-known painting, in which a traveler with

cat. no. 13. Kirchner, *Fanny Wocke*, 1916, woodcut on blotting paper.

a hat and cane is silhouetted on a road against a long horizontal zigzag of mountains.

By 1927 Kirchner had adopted a synthetically abstract tendency in which recognizable forms were exploded to show their many-sidedness. The attempt to achieve visual simultaneity was consistent with Kirchner's decision to turn away from natural appearances and stress the less tangible aspects of experience, the images of the mind. The new approach also allowed for the addition of shapes and movements not present in actuality, and linked and fused several distinctly different pictorial elements. The artist had used unorthodox methods in the past to suggest states of mind. One of the woodcut illustrations for *Peter Schlemihl*, 1915, showed transparent and opaque figures moving through each other, and the woodcut *Fanny Wocke*, 1916 (cat. no. 13), interpenetrated the head and the undecipherable background. In later woodcuts like *Pianist and Singer*, 1928 (cat. no. 20), Kirchner's new outlook united abstract figures with abstract lines of force.

The work of his last decade is a continuous search for the truth of his feelings without regard to stylistic consistency,

cat. no. 20. Kirchner, *Pianist and Singer*, 1928, woodcut on blue blotting paper (at left).

cat. no. 21. Kirchner, *Mary Wigman's Dance*, 1933, woodcut touched with ink (at right).

as though the artist, after long absence from metropolitan centers, had rejected consistency as so much pedantic play-acting. Picasso's influence is noticeable at times in the combination of profile and full-face, but the influence becomes part of Kirchner's sophisticated naiveté and so appears more as parody than as imitation.

A typical example, on the mild side, is *Mary Wigman's Dance*, 1933 (cat. no. 21). In this woodcut realistic anatomy is obtruded upon by nonrealistic elements. Yet it must be said that Kirchner did convey a sense of the dance and create an animated pattern. And in *The Kiss*, 1930 (fig. 4), the compositional device used for connecting the heads also contributes to the strange modernity of the image.

Sometimes the subjects suggest a tragicomic detachment. Sometimes they are in dead earnest, as in the drypoint *Death*, 1930 (fig. 5). Interspersed with these enigmatic compositions is another body of subjects—decisively executed street scenes, skiing scenes, rural landscapes, and town life, all of which show an invincible zest for life.

As decades pass and as the expressionist or confessional aspects of art press more firmly into the criteria of modernism, Kirchner takes on added stature. I believe it is apparent that he was the greatest printmaker whose career began in the twentieth century. This idea, though often unexpressed, lies behind the fierce competition of knowing collectors for the many masterworks in Kirchner's graphic oeuvre. Picasso, the only formidable competitor, produced fewer prints of comparable originality and expressive power. Kirchner's insistence on remaining true to his feelings at whatever cost gives his work, early and late, a remarkably contemporary impact.

fig. 4. Kirchner, *The Kiss*, 1930, woodcut. Photo: © Dr. Wolfgang and Ingeborg Henze, Campione d'Italia.

fig. 5. Kirchner, *Death*, 1930, drypoint. Photo: © Dr. Wolfgang and Ingeborg Henze, Campione d'Italia.

Notes

1. In March 1973, *ARTnews* published my article, "The Monumental Achievement of Ernst Ludwig Kirchner." My first thought was to reprint the piece for this catalogue. But since 1973 the climate of the art world has changed; Kirchner has become much more widely appreciated and the literature on German Expressionism has greatly increased. I have therefore rewritten the piece using different illustrations and more recent information. Some material from the early article is included with the kind permission of *ARTnews*. (Copyright ARTnews Associates 1973)

2. Annemarie and Wolf-Dieter Dube, *E. L. Kirchner: das graphisches Werk*, 2d ed., 2 vols. (Munich, 1980).

3. Georges Bloch, *Pablo Picasso: Catalogue de l'oeuvre gravé et lithographié 1904-1972*, 4 vols. (Bern, 1968-1979). Bloch's final number for Picasso's graphic production, including illustrations, posters, etc. is 2,011. Eberhard Kornfeld has found 11 more items, making the grand total of 2,022. Picasso still remained short of Kirchner by at least 125 prints. I go into this detail because some observers can't imagine any artist exceeding Picasso in output.

4. See Wolfgang Henze's article, "Kirchner," in *German Expressionist Sculpture* [exh. cat., Los Angeles County Museum of Art and the Hirshhorn Museum and Sculpture Garden] (Los Angeles and Chicago, 1983), 29-39. Dr. Henze has tracked down more than a hundred pieces, many of which have disappeared and are known only through remaining photographs and documents.

5. Letter from Kirchner to Curt Valentin, 17 April 1937, Curt Valentin Gallery, New York, 1952, unpaginated.

6. Letter from Kirchner to Valentin.

7. Annemarie Dube-Heynig, *Kirchner; His Graphic Art*, New York, n.d., 22. Originally published in German as *E. L. Kirchner, Graphik*, Munich, 1961.

8. See Antony Griffiths, "The Printmaking Techniques of the Members of the Brücke," in Frances Carey and Antony Griffiths, *The Print in Germany 1880-1933* (London, 1984), 29-39. This catalogue is the most useful work in English on German Expressionist printmaking.

9. Dube, *E. L. Kirchner*, 1:13-14.

10. Carey and Griffiths, *The Print in Germany*, 32-38. In a previously unpublished tape recording of a conversation with Roman Norbert Ketterer, supplied to the British Museum through the courtesy of Mr. Ketterer, Heckel described some of their drastic manipulations with that stone.

11. Quoted in *E. L. Kirchner: Drawings and Pastels*, ed. Roman Norbert Ketterer, New York, 1982, 237. This book includes compendious reference sources, corrected biographical data, and an analysis of Kirchner's styles.

12. My information on the paintings comes from Donald E. Gordon, *Ernst Ludwig Kirchner* (Cambridge, Mass., 1968), a critical catalogue of all the paintings. Dube, *E. L. Kirchner*, is the source for prints. Both catalogues, in different ways, summarize Kirchner's known production year by year, as does Hans Bollingen's biographical digest in Ketterer, *E. L. Kirchner, Drawings and Pastels*, 11.

13. Annemarie Dube-Heynig, *Kirchner*, 86.

PRINTS OF THE BRÜCKE ARTISTS

Andrew Robison

THE ARTISTS GATHERED IN THE second section of the exhibition shared with Kirchner a membership in the artists' group Brücke. The group was formed in Dresden in 1905 by four architecture students in their early 20s, Ernst Ludwig Kirchner, Fritz Bleyl, Erich Heckel, and Karl Schmidt-Rottluff. Their personal association originally grew through a sense of comradeship in their devotion to painting and drawing in a forceful, natural way, seizing and expressing images as directly as possible. The formal program of the Brücke was to unite young, revolutionary forces in art into a common effort, to arrange exhibitions of members' work, and to publicize their work through distributing annual reports and portfolios of prints to subscribing members of the public called "passive members." The title Brücke (Bridge) was given by Schmidt-Rottluff, who explained in his 1906 letter of invitation to Emil Nolde, "one of the aims of the Brücke is to attract all the revolutionary and fermenting elements to itself—that's the meaning of the name, Brücke."[1]

The Brücke expanded with a number of new artist members year by year, including, most notably, Emil Nolde and Max Pechstein in 1906 and Otto Mueller in 1911. However, with inevitable friction between strong individual personalities, Nolde's resignation after a year and a half, and Pechstein's permanent move to Berlin (1909) and subsequent involvement in art politics there, the structured association of the Brücke lasted only a few years. These were crucial years for the artists' development, but by 1913 the group was formally dissolved.

opposite page: cat. no. 31. Nolde, *Dancer*, 1913, color lithograph with hand coloring.

In the active art world of Dresden, the members of the Brücke had access to great collections of old master paintings, drawings, and prints, as well as to an active program of exhibitions of contemporary German and foreign art at commercial galleries like those of Ernst Arnold and of Emil Richter. There were indeed favored artists both old and new, who provoked special interest and resonance in the works of the Brücke—especially Dürer, Cranach, and other early German printmakers, Rembrandt's paintings and drawings, and the works of van Gogh, Gauguin, and Munch. However, directness of expression was their watchword. Thus, the friends felt the widest latitude in simply ignoring artistic conventions for the drawing of form, creation of surface, cutting of the printing matrix, and method of printing, so long as the resulting expression was authentic and successful.

A crucial part of the Brücke sense of authenticity involved the interpenetration of art and life. Models lived or stayed for long periods with artists in their studios, artists sometimes modeling, models and lovers frequently being the same, furniture for daily use being carved or decorated by artists, the studios gradually becoming transformed into works of art as total environments. Another aspect of Brücke authenticity was the naturalness of the model in situation and motion. This emphasis on freedom from convention in model as well as artistic means frequently involved nudity or partial nudity of the models, free of clothing in the studio and in nature, relaxed stances, normal gestures, and above all the body not in a pose but in motion. Love of naturalness and directness of motion sent Brücke artists to woods, lakes, and the seashore for their models to be free, as well as to cabarets for dancers, to the circus for performers, and to the streets for walkers. Thus, the Brücke is far from the common stereotype of German Expressionism based on later manifestations after World War I. While the Brücke certainly sought directness and intensity of expression, what its artists were expressing at this earlier period was typically not anguish and pain but freedom, movement, light, love, and the beauty of the female nude. The Brücke was eminently vital and life-affirming.

The Brücke emphasis on printmaking had to do both with directness and honesty of craft and with creativity of medium. Printmaking as a central means of expression was seen as a revival of a characteristic form of old German art. Printmaking was democratic both in its less expensive methods and in its potentially widespread audience. Finally, the simplicity and boldness of statement traditional in early prints was a link to

direct or popular communication without the elegant refinements of salon art. In terms of creativity of medium, Brücke artists reveled in the uncontrolled surprises of printmaking and in the vast variety of its effects. The image can be created on the matrix with many different drawing materials and methods of their use, but then the numerous possibilities continue with the range of inking and printing (the variety of colors, of preparation of the ink, of wiping, of the ways and order of impressing the plates) as well as the range of supports (different textures of paper, with different receptivity, and in different colors). In their prints the Brücke artists sought to manifest the character of the means used—the actual edges of the matrix, with all its breaks and irregularities, the sense of squashed ink resulting from the pressure of printing, and the particular characteristics of the substance of the matrix, whether stone or wood or metal. As Nolde summarized in 1906, "I want my work to grow from the material, just as in nature the soil from which it grows determines the character of the plant."[2]

After Kirchner certainly one of the most creative Expressionist printmakers was Emil Nolde (1867-1956). Coming from a peasant background in the flat, wind-swept landscape of Northern Germany near the Danish border, Nolde apprenticed as a woodcarver in a furniture factory, and continued that work for five years. Gradually, through his intense desire to become an artist, he made enough time to study drawing and painting both in classes and with various artists, and then secured a position teaching drawing in St. Gall, for six years. From there, after periods in Munich, Paris, and Copenhagen, he returned to his North German homeland. In 1905 Nolde had his first one-man show, at the Galerie Arnold in Dresden. The original four members of the Brücke were struck by his "tempests of color," as Schmidt-Rottluff put it, and immediately asked him to join their group.

Nolde's special power resides in his vibrant color, his technical prowess particularly at etching, and especially in a kind of timeless spiritual intensity which pervades his works. This intensity is evident in all his subjects, whether portrait, genre, myth, nature, or even architecture. It is based on his extraordinary ability to feel and convey what seems primitive, sometimes even animistic forces in the subjects. This is quite different from responding to the abstract forms of primitive art, something characteristic of the Brücke as well as of contemporary French artists, and something Nolde himself did very occasionally after 1909. Rather, the earlier and more constant

sense of the primitive in Nolde's works has to do with his personal response to and real grasp of the power in religion, mythology, folk superstition, and the beauty of natural phenomena. This sense of the primeval in Nolde's work seems the real basis for the common references to him as being the elderly member of the group; in fact, he was only thirteen years older than Kirchner, and only seven years older than Mueller.

The four etchings in this exhibition show Nolde's ability to manipulate the plate for a variety of effects, especially relying on his personal facility with a distinctive type of tonal etching. While Nolde might add the traditional aquatint in his etchings on copper (cat. no. 27), in many of his most striking prints he used iron plates (cat. nos. 28, 29, 30), another tie with early German printmaking, and employed exclusively a much more direct and painterly, as well as more uncontrollable tonal technique. In this technique the plate, except where densely covered by wax or asphalt in certain areas to appear brighter, is simply exposed directly to the biting and pitting of acid without general protection through rosin or other porous ground. This begins in Nolde's etchings as early as 1899, and he quickly learned to capitalize on its richly coloristic and unpredictable effects. The *Church of Saint Catherine* (cat. no. 28) and the *Scribes* (cat. no. 27) show the rich variety he achieved, sometimes intense and brutal, sometimes delicate and fluid.

The two plates from Nolde's justly famous 1910 series on the Hamburg harbor (cat. nos. 30 and 29) are remarkably effective conveyors of that combination of powerful masses, black dirt, mist, and the omnipresence and buoyancy of water,

cat. no. 28. Nolde, *Hamburg, Church of Saint Catherine*, 1910, etching and tonal etching.

cat. no. 27. Nolde, *Scribes*, 1911, etching and tonal etching.

54

cat. no. 30. Nolde,
*Hamburg:
Reihersteigdock*, 1910,
etching and tonal
etching.

cat. no. 29. Nolde,
Steamer, 1910, etching
and tonal etching.

which is the essential environment of great harbors. The prints show Nolde's range within the theme. The dominant bulk of the drydocked freighter contrasts with the tiny steamer in the midst of nature's storm. An open skein of lines with scattered pitting makes palpable, gritty mist as opposed to the deep tone with strange stormy lights and the irregular parallel diagonals of light and dark which create one of the most convincing graphic images of a dense, driving rain. Wispy smoke, which always issues from the funnel even of a docked ship, is conveyed as effectively as the black clouds of the steamer struggling ahead. The water is particularly fine: from the few short strokes and associated tonal pitting of the harbor one senses the water's depth as well as its surface, both its glassy reflection and its movement, while the irregular but echoing curves of various tones in the stormy water, reinforced by the billowing smoke and exaggerated bow breaking the waves, are marvelous conveyors of the violence and power and strange heaving and rolling of an angry sea.

Nolde's two large lithographs in the exhibition make a more immediate contrast among the best of his prints. In its alternation between indicative design and abstract watery brushstrokes, even a kind of natural topography of flowing liquid, the black portrait (cat. no. 26) must be studied and gradually absorbed. As if from a primeval substance in process of taking shape, slowly the features and then the personality emerges of Dr. Gustav Schiefler. The Hamburg Chief Justice was one of the finest critics, patrons, and scholars of the emerging Northern Expressionists and had just this same year (1911) published the first catalogue raisonné of Nolde's prints. The *Dancer* (cat. no. 31), on the other hand, which is surely Nolde's greatest print, makes its impact immediately. It was created in 1913 at the end of an intense eight-week period standing by the stones and presses in a Flensburg lithographic shop, constantly varying states and colors with every impression of a series of prints in an extraordinary burst of creative experimentation. As Nolde said, "The Dancer, the last of these sheets, was supposed to manifest passion and my joy."[3] A sense of primitive, Dionysian force in dance could hardly be better portrayed. The ecstatic rigidity of the dancer's akimbo legs explodes into motion with her flipping skirt and the flow of her nimbly curving arms and splendid undulating shock of hair. The elongated head thrown back into the edge of the composition completes the wild power of the dance with its wide open mouth, tightly closed eyes, and brightly rouged cheeks. Passion and joy!

cat. no. 26. Nolde, *Man in a Top Hat
(Dr. Gustav Schiefler)*, 1911,
lithograph.

Like Nolde, Otto Mueller (1874-1930) came to the Brücke with his artistic personality already formed. He spent two years studying at the Kunstakademie in Dresden, and then ten years painting alone in the Riesengebirge before moving to Berlin in 1908. His themes were constant, especially portraits, lovers, landscapes, and above all else, the nude in nature. Of his 172 prints from 1895 to 1928, over 90 show nudes among plants or trees, usually near or standing or playing in the water.

As opposed to the frequent stereotype of German Expressionism, harmony is the dominant characteristic of Mueller's work: the harmony of man with nature, as his nudes stand, lie, or play in the open; the harmony of forms with each other in his compositions full of echoing lines; and a certain softness, whether in his curvacious or even in his most angular images, from the inevitable curves of the female form tenderly ex-

pressed. In fact, Mueller's obvious love for the female body comes shining through almost every image. His women are simply shown. Slender and lithe, with little facial personality, his figures have a gangly casualness of pose and great directness in portrayal of their physical presence. Authentic simplicity and directness united Mueller with the Brücke in spirit, and he thus shows the range of style the group appropriately included. He joined the group in 1910 when he met other members in a joint exhibition of their pictures rejected by the Berlin Secession.

Mueller created only six woodcuts, five in 1912, and undoubtedly made those in response to the prominence of the medium among other Brücke artists. But he turned even the woodcut to his own purpose. The *Girl Seated between Large Plants* (cat. no. 41), consistent with the blunt, directness of carving characteristic of Brücke works, shows as simple and beautiful a portrayal of youth in nature as a freehand drawing. The plants enclose and protect the girl, as they and the distant peaks echo her form.

Mueller's primary medium was the more fluid drawing of lithography. The two examples here (cat. nos. 39 and 40) show the constancy of his themes and his spirit, even with the newly pronounced, sharp angles which began to appear in his work close to 1920. The girls sit, lie, and stand with utter naturalness in their surroundings. They display their bodies with charming freedom. The angles in their faces, their slender and flatly

cat. no. 40. Mueller, *Two Bathers*, 1921-1922, lithograph.

cat. no. 39. Mueller, *Girl on a Couch*, 1921, lithograph.

opposite page: cat. no. 25. Pechstein, *Variety Dancer*, 1909, color lithograph on yellow paper.

58

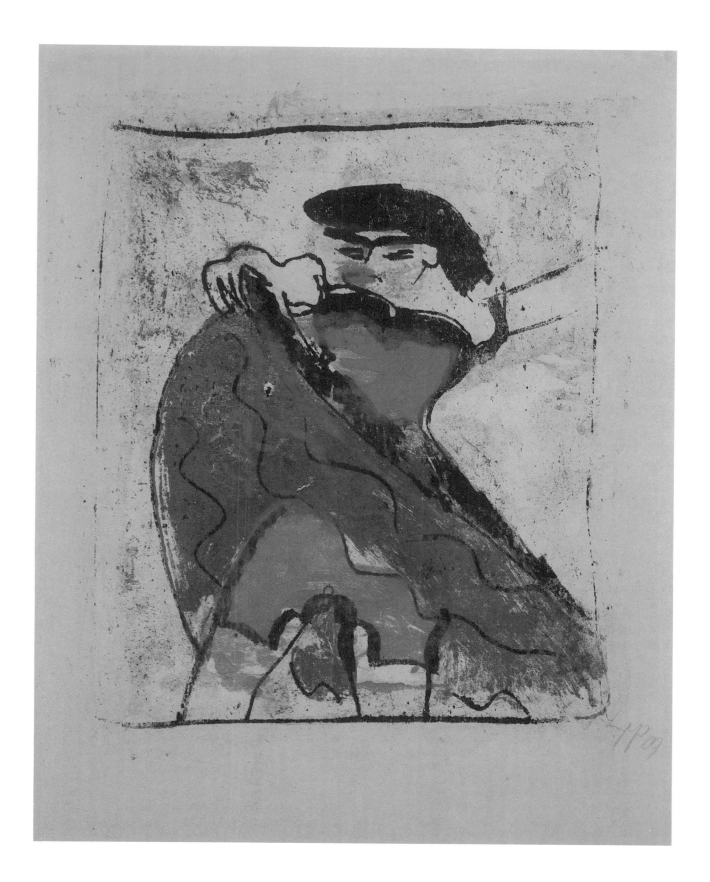

outlined forms, just as those in the woodcut, recall early Med-
iterranean images, especially Egyptian. As Paul Westheim wrote
on Mueller's death, "Hellenism was in his blood and at the
same time something gypsy: the longing for freedom from
bounds and for aboriginalness . . . [he was] an inner Greek, a
seeker of beauty."[4]

Kirchner, Heckel, Schmidt-Rottluff, and Pechstein were
roughly contemporaries in age, born within a few years of each
other in the early 1880s. Thus, they also shared the feature
that the experience of their Brücke association came at an
early point in their artistic development, and was correspond-
ingly important to it. This role of a common endeavor was
especially crucial for Max Pechstein (1881-1955), who was not
as strongly individual an artistic personality as the others. Yet,
in the fermenting context of associations he created excellent
works. Pechstein had a full academic training, beginning with
drawing lessons at the age of ten, apprenticing to a local painter
for four years, and then studying in Dresden for six more years.
In reaction to early German art, and van Gogh, he was begin-
ning to experiment with more spontaneous and expressive
painting about 1906 when he met Heckel and joined the Brücke.

The Kainen Collection contains two of the best of Pech-
stein's early prints. The *Girl* of 1909 (cat. no. 24), with its
elegant hairdo, coy pose, and sinuous, decorative outlines re-
minds one that Pechstein had visited Italy and Paris in 1907,
where he was mainly interested in early Renaissance, Etrus-
can, and tribal art but where he also met Kees van Dongen
and became aware of the Fauves. Nevertheless, in its use of
forceful stray lines and apparently deliberate pitting of the
plate, the *Girl* shows a sense of reveling in qualities of the
graphic medium which is characteristc of the Brücke. His
Variety Dancer (cat. no. 25) of the same year shows just how
forceful a Brücke image Pechstein could create. With swift
drawing and bold lines the artist gives this woman not only
a flurry of motion but also greater personality than his more
carefully drawn *Girl*. The *Dancer* fixes our attention with her
intense gaze. The heavy reticulation of reds and the mottling
of blues on the yellow paper, which Pechstein must have learned
from Kirchner's contemporary experiments, reinforce respec-
tively the extraordinary physical presence of her body as well
as the murky atmosphere of the club with acid artificial lights
in which the dancer whirls wildly.

Erich Heckel (1883-1970) met Kirchner and Bleyl in 1904
when he went to study architecture in Dresden. He left the
Technische Hochschule after one year, and then spent two

cat. no. 24. Pechstein, *Girl*, 1909,
drypoint and etching on tan cardboard.

more as a draftsman in an architect's office. Contemporary accounts refer to him as intense, willful, passionate about art. Through the first decade Heckel's style, like that of most other Brücke members, evolved toward increasingly angular, crystalline forms. Heckel conveyed these sharp, dominantly rectilinear forms effectively in all media, but they have a natural affinity to woodcarving, which he introduced to the Brücke, and thus, of course, to the woodcut.

The *Standing Woman* of 1911 (cat. no. 36) shows Heckel's art in one of the crucial years of transition. The nude still has the exuberant and unproblematic sensuality of the early Brücke. Her miniaturized raised arms serve merely to frame her face and start the in-and-out movement which leads the eye down to her full, heavy breasts, thence to her splendid round hips, and through her pertly overlapping legs to the finishing flair of her poised foot. At both extremes the body is elastically condensed in a reflection of perspectival abbreviation, but truly for the purpose of emphasizing the nude's wonderful torso. Likewise, the expanding sides of the woodblock reinforce the motion downward to her hips, a highly successful use of irregular blocks, which Heckel had begun to employ already in 1908. Here, while the block is boldly carved with a real sense of the knife in cutting lines for her body, which go thick and thin, the nude is still basically drawn in the round. Only at

61

2 8^{30}

Stehender Akt

G Kerkel 19??

her extremities, and especially in the background figures peeping around her arms, do we sense the sharp rectilinear forms to come. Heckel delights in the variety of textures from partially gouged planes which leave lighter flecks and smudges. He uses them here in activating the background, but even more effectively within the nude's form by keeping these textured smudges close to the principal lines and thus softening and rounding her body's outlines at the same time that these outlines remain bold and clear. This effect is enhanced further in the Kainen's proof impression by Heckel's light hand coloring with a flesh tint, again just toward the edges of her form.

By the time of *Lake in the Park* (cat. no. 35) Heckel's style has completed its shift. From 1910 to 1924 Heckel's intaglio work virtually gives up etching in favor of drypoint; the stiff rectilinear scratches of that medium are excellent bases for his new crystalline forms. These sharpened forms are organized to create even more movement than his earlier rounded ones. Light, which bathes the nude in *Standing Woman*, now bounces throughout the image of the *Lake*. The staccato rhythms of the tree trunks, of their zigzag foliage, and of their reflections are continued through widely-spaced parallel hatching, and even through stray textural marks used to show the glassy

cat. no. 35. Heckel, *Lake in the Park*, 1914, drypoint.

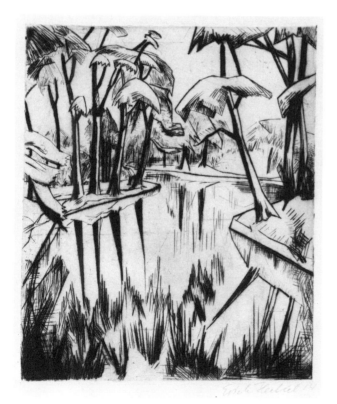

opposite page: cat. no. 36. Heckel, *Standing Woman*, 1911, woodcut with hand coloring.

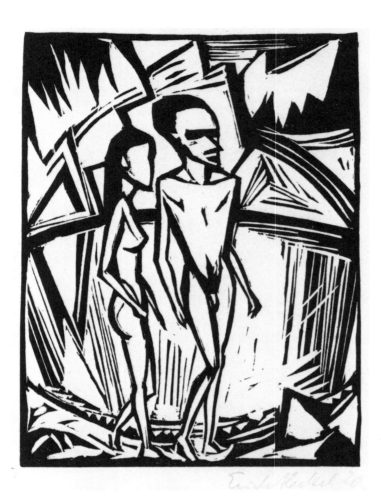

cat. no. 37. Heckel, *Two Figures by the Sea*, 1920, woodcut.

surface of the water. This development in forms and light continues in the woodcut *Two Figures by the Sea* (cat. no. 37). Now the triangular shapes are so dominant, and the hatching on the water's surface so sharp and clearly marshalled in perpendiculars to the background, that the scene appears an arctic lake surrounded by faceted mountains of ice bouncing a blinding light back and forth with the mirror of the water. Even the bodies of the nude couple have become slivers and triangles of light. Heckel's sharply pointed forms could certainly be used to convey pain or melancholy, but here they convey a positive excitement with a world of brilliant light which refracts, suffuses, and organizes the entire environment.

Karl Schmidt-Rottluff (1884-1976) was a school friend of Heckel, and through him met the other three original members of the Brücke when he moved to Dresden, also to study architecture, in 1905. Beginning with highly activated images built from boldly individuated strokes of color, Schmidt-Rottluff around 1910 changed to what would be his primary artistic

preoccupation: the construction of images through planes of color, and the achievement of strength in image through flattening, as if the objects were sculptures hewn in facets from the toughest oak. Many of the specific conventions used to achieve these effects in his figures, the flat noses, large flat lips, concave faces, and striated hatchings, are clearly revived from African and Oceanic sculpture, which the Brücke had originally studied in Dresden.

In his *Chronicle of the Brücke* Kirchner credits Schmidt-Rottluff with introducing lithography to the group, which must have been in 1906. In fact, for the next three years lithography dominated Schmidt-Rottluff's graphic art, though by 1912 he had already created two-thirds of all his lithographs, and the woodcut had taken over as medium of preference. At the end of this period of dominant lithography *Sunset on the Quay*, 1910 (cat. no. 34), clearly shows the artist's simultaneous search for intensity of expression and for simple monumentality of

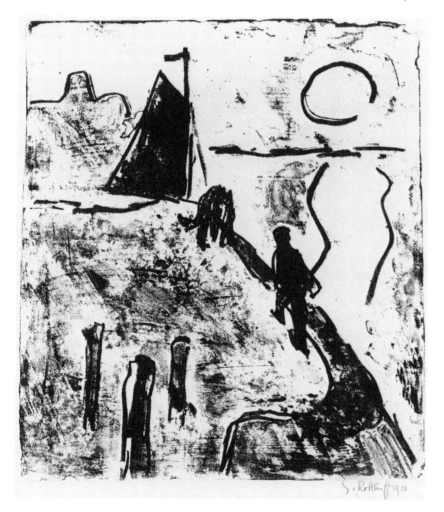

cat. no. 34. Schmidt-Rottluff, *Sunset on the Quay*, 1910, lithograph.

cat. no. 38. Schmidt-Rottluff, *Nude*, 1909, woodcut.

form. In this search landscapes were crucial through his earlier years. The geometric masses of trees, buildings, boats, roads, and water pointed the way to simplification of form. Yet the free autographic stroke of lithography, and its possibility for rich and natural texture—as here—offered Schmidt-Rottluff clear outlet for the sense of directness, swiftness, and authentic expression which he sought.

Leaving aside his earliest Jugendstil works, it was in 1909 that woodcut took prominence among Schmidt-Rottluff's graphic media, and remained overwhelmingly dominant for the next decade. A marvelous example from that first year is the *Nude* (cat. no. 38), rich in the textures of carving and gouging which color the figure and bed at the same time they

manifest the woodiness of the medium and the process of artistic creation. Typically for the early Brücke, this nude is a real woman, a sensual presence heavy in corporeality with full breasts falling onto rounded waist and stomach. Yet the centralized condensation of her figure and the emphasis on heavy black outline, heightened by a halo of white, already show Schmidt-Rottluff's search for simple, monumental form in the nude. By the time of the *Woman with Unbound Hair*, 1913 (cat. no. 32), the artist has found it. Now relying on the flatness of wood more than its textural qualities, he has geometricized and simplified the seated nude's forms while losing nothing of her sexual presence. Indeed, the sweeping, rounded lines of her heavy thighs and hips, and the enlarged circles of her breasts, make her sexual and reproductive powers symbolic determinants of her form just as with a primitive fertility goddess.

cat. no. 32. Schmidt-Rottluff, *Woman with Unbound Hair*, 1913, woodcut.

cat. no. 33. Schmidt-Rottluff, *Portrait of Guthmann*, 1914, woodcut.

Schmidt-Rottluff's control of geometric simplification and monumentality through reduction to planes, so congenial to the flat expanses of a woodblock, can be seen even more crisply, with no hint of depth, in his *Portrait of Guthmann*, 1914 (cat. no. 33). The large shapes of Guthmann's body are at once flat forms yet manipulated to give a sense of characteristic personal pose. The sharp angles of head, body, and background pattern, and especially the similar, long parallels, alternating between white and black, from wall hatching to chair spindles to shirt to extended fingers, unite the image in flat echoing forms which nevertheless convey the variety of the environment. The organization of white and black, so that the only area of complex interaction in a proximate variety of lines and forms is the expanded head of Guthmann, projects his face out of

the image and seizes the viewer with a sense of his presence in spite of the simplification of his features.

Schmidt-Rottluff's artistic creed was best expressed by him in the same year as the *Guthmann*, and effectively stands for all the Brücke artists in their variety and their common ground. When asked by the periodical *Kunst und Künstler*, at a time of frequent artistic manifestoes and critical metaphysics abroad, about the artistic program of the new, young German artists, Schmidt-Rottluff replied:

> I am familiar with no "new artistic program." I absolutely do not know what that could be. If one could speak at all of something of a kind such as an artistic program, then in my opinion that is ancient and eternally the same. It is only that art is always and again manifesting itself in new forms, since there are always and again new personalities—its essence, I believe, can never change. Possibly, I am mistaken. But for myself I know that I have no program, only the inexplicable longing to grasp what I see and feel, and to find the purest expression for it.[5]

Notes

1. As quoted in Wolf-Dieter Dube, *The Expressionists* (London, 1972), 32.
2. Quoted in Peter Selz, *Emil Nolde* (New York, 1963), 51.
3. Quoted in Martin Urban, ed., *Emil Nolde—Graphik* (Seebüll, 1975), 25.
4. Paul Westheim's memorial notice in *Kunstblatt* (November 1930, 347) as reprinted in Florian Karsch, *Otto Mueller: Zum Hundertsten Geburtstag: Das Graphische Gesamtwerk* (Berlin, 1974), 9.
5. Quoted in Gerhard Wietek, *Schmidt-Rottluff: Graphik* (Munich, 1971), 12.

Revolution
10ᵗᵉ November

Lovis Corinth

PRINTS OF THE 1920s: AN ART OF ENGAGEMENT

Christopher With

THE THIRD ROOM OF THE EXHIBITION contains a fine cross section of prints from the early 1920s, soon after the end of World War I. Many of the artists had worked at the same time as artists in the Brücke. Apparent in much of their work is the experience of that war as well as their keener awareness of cultural and political events. Indeed, one of the pieces (cat. no. 44) is inscribed with the precise date of the war's end: November 10. Surrounded by an easel on the right and canvas frames on the left, it is a self-portrait of the artist Lovis Corinth (1858-1925). The attention to effects of light and shadow reminds one that Corinth was an impressionist. His art is based as much on the registering of visual reality as on the expression of emotion. The prints displayed here reveal that subtle blend of approaches: his evocative use of tone and texture ranges from the thick pockets of black shadow in the deep recess of *Entombment* (cat. no. 43) and throughout *Death and the Old Man* (cat. no. 47) to the feathery, smoky film of *The Kiss* (cat. no. 45) and *Self-Portrait* (cat. no. 44). This marvelous versatility in handling the interplay of light and shadow places him among the masters of German impressionist art.

Born in East Prussia, Corinth was trained at the art academies of Königsberg and Munich. In the years 1884 to 1887 he lived in Paris where he attended the Académie Julian. After some traveling, he settled in Munich in 1891. Having eventually established a reputation there, in 1901 he moved to Berlin where he lived until his death, becoming one of the

opposite page: cat. no. 44. Corinth, *Self-Portrait*, 1918(?), drypoint.

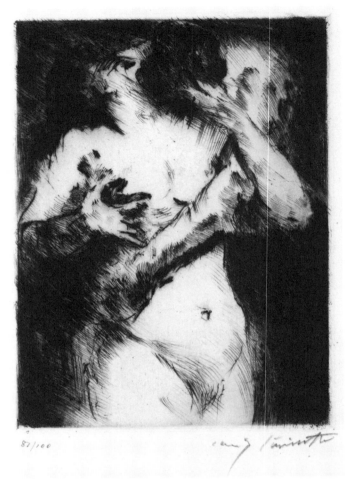

81/100

cat. no. 45. Corinth, *The Kiss*, 1921,
drypoint.

cat. no. 47. Corinth, *Death and the
Old Man*, 1920/1921, soft ground
etching.

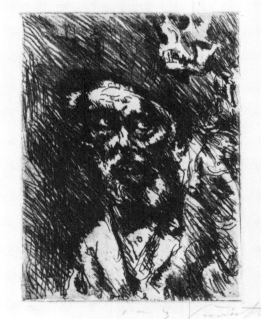

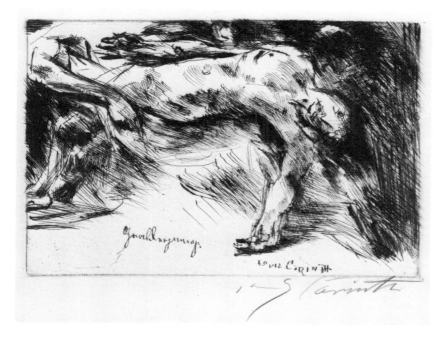

foremost exponents of the increasingly fashionable German variant of impressionism.

Germany's defeat in the war, the abdication of the Kaiser, Wilhelm II, the foundation of a German Republic—commonly known as the Weimar Republic—and the resultant social, economic, and political upheavals (*Self-Portrait* [cat. no. 44] has the word *Revolution* scratched into the plate) clearly influenced the choice of some of Corinth's subject matter. The drypoint *Entombment* is on one level a religious picture, but by eliminating nearly all detail and focusing solely on the recumbent human form, Corinth pared the spiritual content down to a minimum. Indeed, the German word of the title was added to preserve the religious connotation. However, it is this allusion to the concept of death which allows one to interpret the image as a lament on the death and suffering of German soldiers and civilians during the war and its immediate aftermath, as well as a somber mourning for the passing of an age and of a longstanding social order. Its poignancy is all the more intense since the piece lacks any of the traditional Christian references to the redemptive aspect of human sacrifice and martyrdom.

The same sense of gloom and despair also underlies the soft ground etching, *Death and the Old Man*. It is one of five images published by Euphorion Verlag in Berlin at the beginning of 1922. Known collectively as *Dance of Death IV*, the series deals explicitly with Corinth and his immediate milieu.

Other prints in the set show Corinth himself, his wife Charlotte, their son Thomas, and another artist couple who were close personal friends. The old man in the work shown here has not been identified, but is thought to be Corinth's father, to whom the artist had been totally devoted.

Since he preferred to work in etching, drypoint, and lithography, the use of soft ground etching for *Dance of Death IV* is unusual within Corinth's oeuvre. But it was consciously employed here to achieve the brooding atmospheric quality which makes this image so visually powerful. By the early 1920s, when *Dance of Death IV* and *Henny Porten* (cat. no. 46) were made, Corinth was making over 100 prints a year. Although he did some remarkable etchings in 1894-1895, he abandoned printmaking for roughly a decade owing to the lack of any market for his graphics. Only in the years after 1906-1908 did he again return to printmaking, creating at first only a few prints each year. At present, 918 graphics by Corinth have been catalogued.

In 1919, the artist Christian Rohlfs (1849-1938) was seventy years old. Remarkably, it was during this late stage of his life that Rohlfs produced some of his most significant creations. Rohlfs' activity as a printmaker spans the years from 1910 to 1926. A fine example of his very early style is the woodcut *The Three Wise Men* (cat. no. 66) done about 1910. Although Rohlfs is known to have done linocuts and stencil prints, the majority of his 168 catalogued graphics are woodcuts. The art of the woodblock had been revived within Germany by the members of the Brücke, who preferred it to other media because of its strong tonal contrasts and its rough, jagged lines. While Rohlfs' use of this technique was clearly indebted to the Expressionists, he did not share their ultimate goals. Like Corinth, he was more fascinated with external reality but, unlike the former, he transmuted his images into spiritual symbols.

According to Rohlfs, artistic creation was a discipline necessarily detached from the everyday. Its free, unhindered flights of fancy were only possible when liberated from the tyranny of an overly literal reliance upon the factual and the objective. "We [artists] should not be reformers of the world," Rohlfs once wrote. "The more unintentionally we work, the better ... and it is better for humanity if we trouble ourselves as little as possible with everyday concerns."[1]

Nevertheless, on rare occasions, Rohlfs did specifically address his art to contemporary events. A haunting case in point is the woodcut *The Prisoner* (cat. no. 69) of 1918. It is his

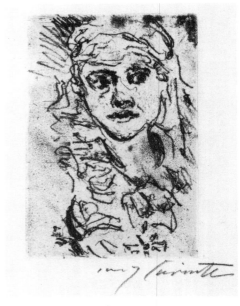

cat. no. 46. Corinth, *Henny Porten*, 1923, soft ground etching.

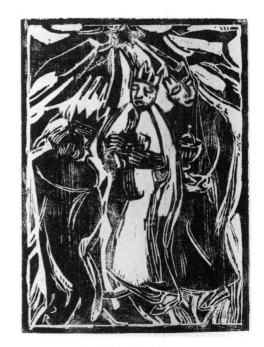

cat. no. 66. Rohlfs, *The Three Wise Men*, c. 1910, woodcut.

74

cat. no. 69. Rohlfs, *The Prisoner*, 1918, woodcut.

supreme comment on World War I and human culpability. As the work's title implies, the image is of a man behind bars. His hands firmly grasp the bars at the level of his face, which wears an expression of uncomprehending intensity. It is as though man can see yet not understand, is willing to act yet is constrained—perhaps by his own pusillanimity—from actually doing so. In the background, the flat, angular blocks of white and black exist in a tense relationship with one another. They may imply the literal forces of good and evil whose confrontation is being waged without mankind's involvement or knowledge. Man, in Rohlf's terms, is the pawn of forces beyond his grasp and thus subject to their whim and fancy. "Men," he once stated, "progressed little; they make war and everything is again as it was."[2]

75

cat. no. 68. Rohlfs, *Susanna in the Bath*, c. 1916/1917, woodcut.

Yet even in a work like *The Prisoner*, Rohlfs did not lose sight of his overriding aesthetic ideal. This is most apparent in two aspects of the print. First, it was printed with thick, crusty ink which, in some areas, gives the work a rich impasto effect. Rohlfs produced this result by mixing other compounds into the printing ink, perhaps egg yolk or soap. Secondly, the work has a somewhat blurred, out-of-focus quality. This is because Rohlfs dispensed with the normal printing press and relied instead on the pressure he applied with a heavy box, an iron roller, or his own hand. Taken together, these features make one aware that the print is both product and process. We are just as aware of what the artist's message was as of how it was achieved. And it was through this latter aspect that Rohlfs not only loosened the bond of *The Prisoner* with perceptual, factual reality, but also infused it with his personal brand of creative inspiration.

Much the same kind of effect can be observed in Rohlfs' woodcut *Susanna in the Bath* (cat no. 68). Its implied theme of Susanna and the Elders has been totally subsumed within a decorative arabesque. The thick, yet generally uniform lines,

coupled with the sheet's flat two-dimensionality, recall medieval stained-glass windows. The soft irregular tones of the ink lend the sheet a delicate, even fragile sensation of insubstantiality.

Perhaps the most fascinating example of Rohlfs' concept of art as a delicate, intangible web is the sheet entitled *Walkers* (cat. no. 67). It is a colored woodcut in which red ink has been printed on a very coarse-grain cloth. It is only the diagonals at the top and the legs at the lower right that convey the impression of figures fleeting across the sheet. Otherwise, the image is a delightful abstract chimera. This impression is further intensified by the manner in which the ink has adhered to the fabric. The rough, irregular weave of the material has caused the ink to attach itself in an uneven and mottled fashion. Though some pockets of deep red exist, the color seems mostly so insubstantial, so fragile, as to be nonexistent. In *Walkers*, reality (both as recognizable shape and as defining color) has been dissolved into the delicacy of Rohlfs' poetic vision and completely subordinated to the dictates of artistic intention.

A far more committed art than that of Christian Rohlfs was produced by Käthe Kollwitz, née Schmidt (1867-1945). Trained in both Berlin and Munich, she originally wanted to be a painter, but was quickly convinced that her real talent lay in drawing and printmaking. With the exception of some pieces of sculpture, her oeuvre consists solely of graphics and sketches. At the age of eighteen Käthe Schmidt became engaged to Karl Kollwitz. They were married in 1891 after he had qualified as a doctor. Together the couple set up residence in northern Berlin in a poor, working-class neighborhood where Karl practiced medicine. They continued to live in this part of the capital until the very last years of her life. It was perhaps what she saw and experienced there that led Kollwitz to believe in the artist's obligation to establish a connection between art and the people. "I confess," she wrote, "that a pure art . . . is not my art. . . . I want to have an effect on my time, in which human beings are so confused and in need of help."[3]

cat. no. 70. Kollwitz, *The People*, 1922/1923, woodcut.

Her sense of engagement with all those who struggle and suffer gained a deeper dimension when, at the beginning of World War I, her younger son Peter was killed. Although the tragedy caused severe bouts of depression, it deepened her resolve to create politically engaged art. Her approach shifted from narrative to a more explicit treatment of general ideas.

A moving example of this change is the woodcut *The People* of 1922-1923 (cat. no. 70). The image was the seventh in a series of prints done for a folio with the bare title *War*. An echo of her own painful experience reverberates throughout the set. *The People* carries the message that anguish and pain can only be withstood and overcome through solidarity with all others who grieve and mourn. A united people can provide the strength and renewal unavailable to the isolated individual.

Kollwitz first began to make woodcuts in 1920. Although largely self-taught in the use of this medium, she—like the members of the Brücke turned this handicap to good account by devising her own unique woodcutting style. In *The People*, for example, Kollwitz allows the black to dominate, while illuminating only select aspects of the human form around the periphery of the image—in this instance, assorted heads and hands. Since the cut areas are so stylized, we read them as abstract and are consciously aware of each gouge made in the woodblock. The uneven dispersal of darks and lights around the sheet not only creates a sharp visual tension, but also produces a bold modulation of values. This kind of starkly dramatic interchange between tones and between different textures has few precedents in relief printmaking.

While the prints of Käthe Kollwitz are well known, Bernhard Kretzschmar (1889-1972) is one of the few artists represented here who has still to receive proper recognition in Europe and America. Born in Saxony, he began his career as a decorative painter at the age of fifteen. By 1909 he had saved up enough money to enroll in the School of Applied Arts in Dresden, transferring in 1911 to the Academy of Art. With the exception of two years spent in the army medical corps in 1917-1918, he remained at the Academy until 1920.

After finishing his studies, Kretzschmar took up residence near Dresden in the small suburban town of Gostritz. Throughout the 1920s and 1930s he specialized in scenes of the life and customs of the petit-bourgeois and artisan classes. In 1945 his studio and its contents were destroyed in the allied bombing of Dresden. Nevertheless, Kretzschmar remained in Saxony and in 1946 was appointed to a professorship at the Dresden Academy.

We do not know anything about Kretzschmar's early style since in 1920 he destroyed most of his work. Thus the prints exhibited here all belong to his mature phase. They are all etchings, the graphic technique which he generally preferred. Of the four graphics, the two earliest are *My Wife* (cat. no. 48) and *Steamers* (cat. no. 50).

In *My Wife*, the woman looks off to her left and downward. This choice of pose conveys an impression of a slightly sad, resigned, yet stoic individual. The soft tone of the lines, the diffuse light, and the series of broad sweeping archlike curves of the hands and the face further contribute to the image's effect of calmness and inwardness.

Unlike *My Wife, Steamers* is full of frenetic energy. Its images—people, waterway, boats, streetcar, bridge—are all schematically rendered and disproportionately arranged across the sheet. This rapid execution not only conveys an image of a scene quickly observed, but also allows one to sense the bustling activity along the riverfront. This feeling is heightened by the random tonal lines which run erratically over the page. Reminiscent of similar effects achieved by Emil Nolde in his scenes of Hamburg harbor (cat. nos. 29 and 30), they wonderfully evoke the scene's noise, smog, and soot.

It is, however, for works like *Lunch Hour* (cat. no. 49) of 1921 that Kretzschmar was best known during the 1920s and

1930s. Here, three workers are observed on their way to lunch with their lunch pails in hand. They have been depicted with the same affection which marks the best of his images of lower-class life in Dresden and its environs. In the background, additional workers can be glimpsed just emerging from the factory, while on the sidewalk, others walk about including one cripple. The composition has been given an unnaturally steep perspective. This tends to bring the whole work closer to the picture surface, and gives the scene a feeling of claustrophobia. It also places greater emphasis on the three foreground figures whose massive frontality and intense gaze unsettle the viewer. In this unabashed confrontation the artist seems to take the side of the workers.

Like the Expressionists, many artists working in the 1920s had a fascination for portraiture, especially self-portraiture. Perhaps the best among these was Ludwig Meidner (1884-1966), three of whose self-images are included here (cat. nos. 52, 53, 54). Indeed, in 1920 this subject succeeded all others as Meidner's most vital genre. For him, it was at once a form of analysis, confession, and affirmation.

Born in Silesia, Meidner began his training in 1903 at the Breslau Academy of Art. In 1906-1907, he spent a year of study in Paris. On his return to Germany, Meidner settled in Berlin.

cat. no. 49. Kretzschmar, *Lunch Hour*, 1921, etching with tonal wiping.

In 1935 he moved to Cologne to teach art at a Jewish school. A Jew himself, he was forced to flee to England in 1939. Several years after World War II he returned to Germany and died in Darmstadt in 1966.

The three self-portraits were done either as drypoints or etchings. These two media seem to have been the sole techniques he employed. While his earliest drypoints date from 1913, he only began working with etchings several years later. In doing portraiture, Meidner urged artists to "press together wrinkled brow, root of nose and eyes. Dig like a mole down into the mysterious deep of the pupils and into the white of the eye and don't let your pen stop until the soul of that one opposite you is welded to yours in a covenant of pathos."[4]

This attempt to pierce the soul, as it were, of the sitter and to give it an appropriate artistic form explains Meidner's extreme cropping of the figure to include basically only the head. Likewise, his belief that the eyes are the windows of the soul

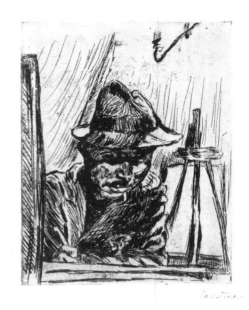

cat. no. 53. Meidner, *Self-Portrait in a Hat*, 1922, etching.

cat. no. 52. Meidner, *Self-Portrait*, 1926, drypoint with tonal wiping.

led him to give them pronounced importance. Of Meidner's three prints, the one that most clearly displays this passionate involvement is the drypoint *Self-Portrait* of about 1920 (cat. no. 52). The outline of the head is angular and bony; the lines describing the face are harsh and choppy. In the darkened area around the eyes, the white of the left pupil hauntingly emerges out of the depths to fix the viewer with an intense piercing gaze. Everything about this image bespeaks a fervent, unrelenting need to link physiology with the complexities of the human psyche.

Meidner's two etchings—*Self-Portrait with a Needle* of 1919 (cat. no. 54) and *Self-Portrait in a Hat* of 1922 (cat. no. 53)—do not display the same high-keyed intensity. The faces are softer, the lighting less dramatic, the defining lines more regular and systematic, and a bit more detail has been included. Yet here too, it is the eyes that catch one's attention and remind the viewer of the intense emotions informing all of these sheets. Also interesting is Meidner's portrayal of himself as a working artist and craftsman rather than as the fervent visionary of the drypoint *Self-Portrait*.

The works of the artist Walter Gramatté (1897-1929) are as varied and diverse as the techniques he employed to produce them. Born in Berlin, the youth's first truly memorable experience was that of the World War I. At the age of seventeen he joined the army as a medical orderly. Not only did his experiences disgust him with war, they also made him conscious of man's mortality and isolation in a disordered world.

While serving on the front in Belgium and France, he was severely wounded twice. The long-term consequences of those injuries contributed to his untimely death in 1929. While still in the military, Gramatté began his artistic training at the Berlin Royal Academy. In 1919 he left art school and began his professional career. After a series of personal setbacks, Gramatté emigrated to Spain in 1924. Two and a half years later, he returned to Germany for good. In 1928, his illness became so severe that he had to be hospitalized. A few months later, in February 1929, he died.

Unlike the majority of artists who evolve a particular style and then never vary it, Gramatté consciously strove to avoid all such rigidity. Rather, he sought to probe the expressive potential of each technique. Hence, if there is any consistency it is within his use of a particular medium rather than throughout his oeuvre as a whole.

The most significant thing for Gramatté was to find the best medium capable of conveying his message. In many in-

cat. no. 54. Meidner, *Self-Portrait with a Needle*, 1919, drypoint.

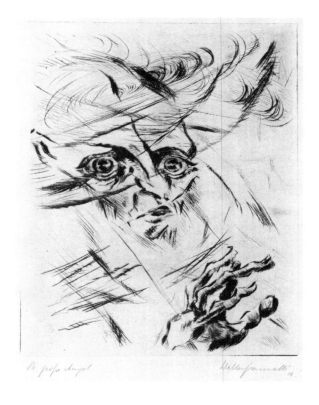

cat. no. 65. Gramatté, *Burial*, 1916, linocut on japan paper (at left).

cat. no. 61. Gramatté, *The Great Anxiety*, 1918, drypoint (at right).

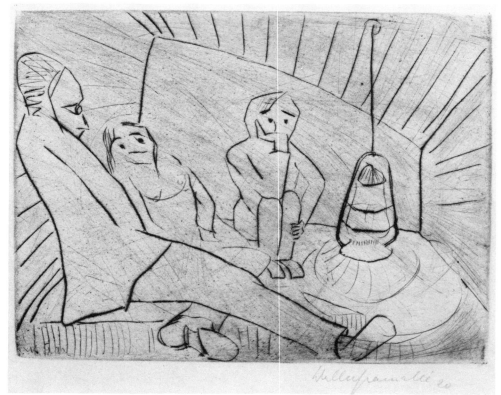

cat. no. 59. Gramatté, *Three People in a Cabin*, 1920, drypoint.

stances, the content is one of loneliness, fear, death, alienation, and despair, all clearly the aftershocks of his years in the military (cat. nos. 59, 61, 62, 63, 64, 65). At other times, the pieces are more introspective, mellow, and poetic (cat. nos. 58 and 60). In these latter graphics, the calming influence of his adored wife can be discerned.

The earliest print by Gramatté in the exhibition is the linocut *Burial* of 1916 (cat. no. 65). (In 1920 he would abandon relief printmaking entirely.) Its rich tones, its rhythmic linearity and abstract patterning are visually beautiful. Only when one notices that the snaking black line in the middle is a funeral procession does one grasp the poignancy of the scene.

The four drypoints (cat. nos. 59, 61, 62, and 64) were done in the years between 1918 and 1920. *The Fall into Infinity* (cat. no. 64) was the fourth illustration for the story *The Rebel* by Manfred Georg, which appeared in *Marsyas* in 1918. While stars sparkle in the sky, black nothingness awaits the falling figure at the bottom of the page. The disproportionally large hand underscores the anguish of the figure and typifies the rootlessness of all rebels. In *The Great Anxiety* (cat. no. 61) the same bony hand reappears. Here too it is a symbol of alienation and loss. The hand, together with the figure's staring eyes, and the swirling lines of confusion about the head, aptly characterize the unsettled condition of Germany in the traumatic years following World War I.

This piece should be considered in relation to another drypoint of 1919, *Weary Soldier* (cat. no. 62). The figure of the tired soldier has been extremely simplified. One effect of this is to call greater attention to the areas lying in deep shade— the eyes, hands, and mouth, the most expressive parts of the body. The entire delineation of the form bespeaks despair and enervation. It seems to describe the response of many people to the events taking place in the early 1920s.

The drypoint *Three People in a Cabin* of 1920 (cat. no. 59) relies much more heavily on outline than do the previous three works. A marvelous atmospheric effect is produced by the delicate tracery lines, somewhat reminiscent of Bernhard Kretzschmar's *Steamers* (cat. no. 50). The light of the lantern has been marvelously suggested by the area of off-white around the lamp's base. The cramped cabin offers no escape for the figures inside its slanting structure. All three figures appear to have withdrawn inside themselves, and stare vacantly into the space around them. The absence of any explanation for the mystery and despair of this work makes these feelings all the more poignant.

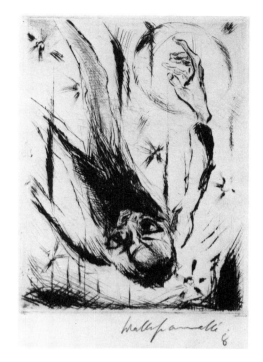

cat. no. 64. Gramatté, *The Fall into Infinity*, 1918, drypoint.

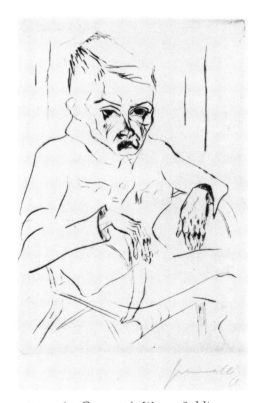

cat. no. 62. Gramatté, *Weary Soldier*, 1919, drypoint.

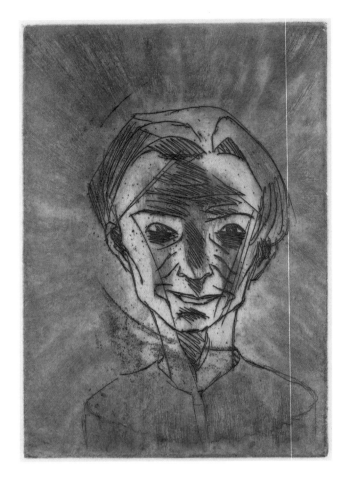

cat. no. 60. Gramatté, *The Couple*, 1922, color etching and abrasion, on japan paper.

cat. no. 58. Gramatté, *Smiling Head, Self-Portrait*, 1923, color etching and abrasion, on japan paper.

A noticeably different mood is conveyed by the two color etchings of 1923, *The Couple* (cat. no. 60) and *Smiling Head* (cat. no. 58). Here the mood seems quieter, more introspective and analytic. Both pieces have been printed using green ink. *The Couple* portrays Gramatté himself at the right side looking directly out of the sheet. The figure seen in profile asleep at the left is his musician wife, Sonia. She is said to have had a calming influence on both the artist and his art. The etching originally appeared as the sixth picture in a nine-print portfolio entitled *The Face*.

The most striking part of *The Couple* is its execution. The lines have been etched deeply into the plate making each line stand out in its velvety richness. The left side of Gramatté's body has been shaded with a series of rapid horizontal strokes which terminate in a band of deep green across the entire length of the sheet. This band was produced by applying sandpaper directly to the plate and then printing the results.

Smiling Head, also executed in 1923, is another self-portrait. The dispersal of the green tones concentrically outward from

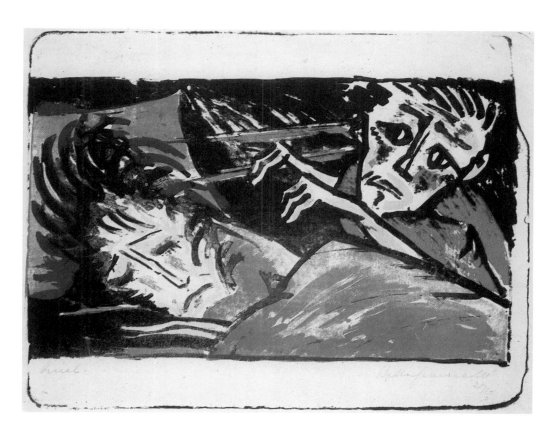

cat. no. 63. Gramatté, *Torment*, 1920, color lithograph on blotting paper.

the face suggests some sort of inner illumination. It makes the laughing, pleasant face of the artist appear saintly as well as demonic.

In addition to this broad array of media, Gramatté also explored the expressive potential of lithography. A stunning example of his use of this technique is the print *Torment* of 1920 (cat. no. 63). Done in vivid tones of green, black, yellow and red, it depicts one figure's anguished concern for his sleeping (dead?) companion. The harsh shapes, the lack of perspective, the crowded space, disregard for proportions, and rapid application of color clearly heighten the psychological drama of the subject. The piece strongly suggests the direct influence of the Brücke. Both Karl Schmidt-Rotluff and Erich Heckel were friends of Gramatté and his lifelong supporters.

Notes

1. Carl Emil Uphoff, *Christian Rohlfs* (Leipzig, 1923), 14.
2. Uphoff, *Rohlfs*, 14.
3. Lucy R. Lippard, "Foreword," in *Käthe Kollwitz: Graphics, Posters, Drawings*, ed. Renate Hinz (New York, 1981), xxiii.
4. Victor H. Miesel, *Ludwig Meidner: An Expressionist Master* [exh. cat., the University of Michigan Museum of Art] (Ann Arbor, 1978), 16.

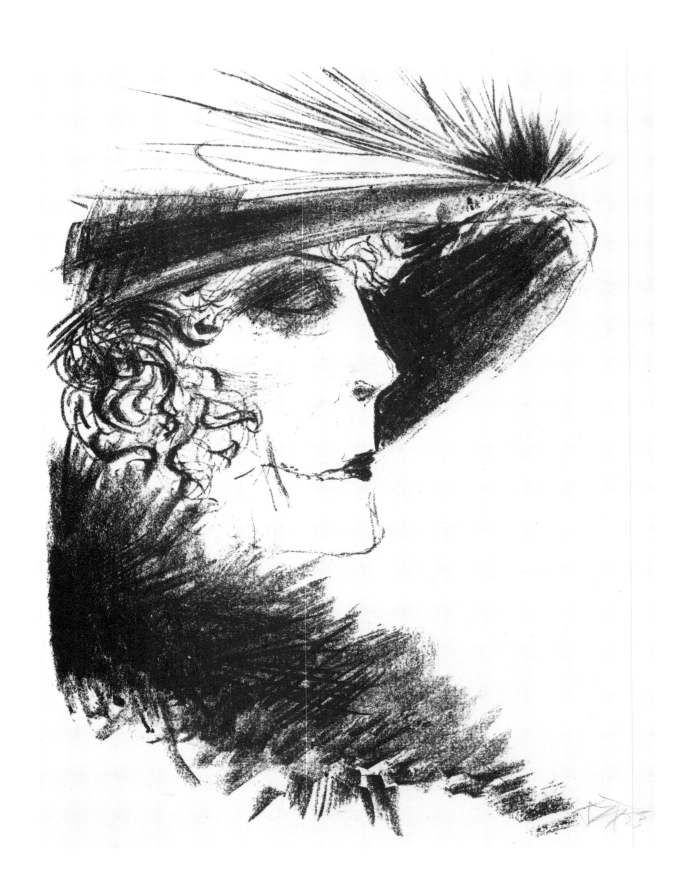

PRINTS OF THE 1920s: A NEW DIRECTION

Christopher With

THE LAST ROOM OF THE EXHIBITION presents the prints of a slightly younger generation of artists. As the decade of the 1920s wore on, a period of relative stability entered German history. The horrors of the war, the dislocations caused by revolutionary turmoil, and the misery engendered by economic hardship did not disappear but rather were glossed over by a veneer of growing prosperity and political stability under the successive democratic governments of the Weimar Republic. With the worldwide economic collapse of 1929-1930, instability and disorder resurfaced in Germany. In this time of internal stress, extreme political factions flourished. One of them, the National Socialist German Workers Party, would eventually emerge victorious when its leader, Adolf Hitler, was appointed chancellor on 30 January 1933.

Although much of the work of this younger generation lost a great deal of its expressionistic edge, it did not abrogate its socio-critical vantage point. The artist who best exemplifies this approach is Otto Dix (1891-1969). He maintained that he sought to depict reality without emotion and without suggesting causes. Yet the very choice of scenes was self-revealing. Precisely because the expression of his ideology was deliberately constrained by the discipline of detached observation, his images vibrate all the more with a deep—if cold—condemnation and accusation.

Dix's first post-War prints were various woodcuts made in 1919-1920 in an Expressionist style. A fine example of these

opposite page: cat. no. 82. Dix, *Lady in a Feathered Hat*, 1923, lithograph.

89

works is a piece entitled *Apotheosis* (cat. no. 80). Originally printed in 1919, it was included along with eight other prints in *Woodcuts II*, a portfolio of nine woodcuts published in 1922. At the center of the image is an amply endowed naked woman. She is the metaphor for everything obtrusively elemental and blatantly erotic. All around her, like the wings of a pinwheel, revolve fragmented images of men and architecture. They are all caught up in a frenetic maelstrom of lust, ecstasy, and desire. The fragmentation of the planes and the sense of swirling images betray the influence of cubism and futurism.

In *Apotheosis* Dix glorifies the magnetic appeal of woman while castigating the folly and weakness of man. His fascination with this theme gave Dix a reputation for rebellious vulgarity and poor taste. Although less overtly erotic, it may be assumed that the lithograph *Lady in a Feathered Hat* (cat. no. 82) is a further manifestation of this theme. Here the title is perhaps ironic, for the woman's hard features, excessive make-up, and overly sumptuous clothing suggest she is a prostitute.

Lady in a Feathered Hat was published in 1923, the year that Dix began to experiment with lithography. In the same year he did the large lithographic portrait of the German conductor *Otto Klemperer* (cat. no. 79). This graphic work presents Klemperer as a refined, earnest, perhaps somewhat stern individual—a very different impression from that conveyed by *Lady in a Feathered Hat*. While both works capture their subjects in rather realistic fashion, the attempt to expose something of the sitter's personality betrays the continuing influence of Expressionism. In addition to his other subjects, Dix was well known as a portraitist.

Dix's central achievement as a graphic artist, however, was the cycle of fifty etchings collectively known as *The War*, issued in 1924 and published in five portfolios. Two years before, Dix had moved from Dresden to Düsseldorf in order to study intaglio techniques with the master printer Wilhelm Heberholz. The inspiration for the entire portfolio were the hundreds of drawings Dix executed while serving as a frontline gunner in the World War I. The work was an immediate success, and won great critical acclaim. More than any other work, it was seen as having captured best the country's experience of war. Despite the success of *The War*, Dix's graphic production ceased totally in 1926 and was only resumed in 1948.

One of the sheets from *The War* is included in this exhibition. Entitled *Dance of Death, Anno 17* (cat. no. 81), its subject is the Battle of the Somme. What at first glance appears

cat. no. 80. Dix, *Apotheosis*, 1919, woodcut.

cat. no. 79. Dix, *Portrait of Otto Klemperer*, 1923, lithograph.

cat. no. 81. Dix, *Dance of Death Anno 17*, 1924, etching, aquatint, drypoint, and burnishing.

to be a purely abstract pattern of lights and darks turns out to be a particularly horrifying image of dead soldiers ensnared in barbed wire. The lighter areas were created through the use of aquatint. They suggest sun (moon?) light and the onset of physical decay.

Another artist who abandoned the graphic medium at a certain point in his career was Paul Kleinschmidt (1883-1949). Trained in Berlin and Munich, he settled in Berlin in 1905. After serving in World War I (in a fire brigade), he lived in various parts of Germany and also traveled widely abroad, including a long visit in New York in the summer of 1934. In 1936, he fled Germany only to be forcibly returned in 1943. Prohibited to paint by the Nazis, he nevertheless continued to work in secret. He died shortly after the end of World War II.

Although his most significant graphic works were created during the 1920s, he stopped making prints for good in 1930. Thereafter he only produced paintings and drawings. The five pieces by Kleinschmidt in the exhibition are all drypoints and were made in the years between 1922 and 1924.

Mountain Rapids (cat. no. 75) is of some interest since pure landscapes were not frequently done during this era. Yet this is not nature observed realistically, but nature seen through the artist's temperament. The highly individualized lines delineating both the rushing water in the foreground and the mountains and trees in the background energize the landscape

cat. no. 75. Kleinschmidt, *Mountain Rapids*, 1924, drypoint.

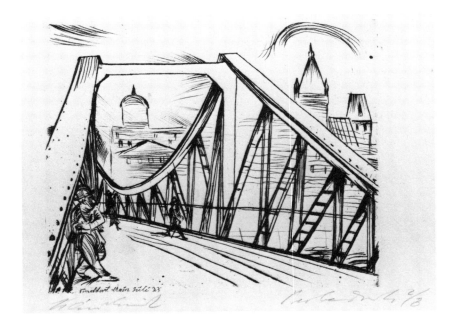

cat. no. 73. Kleinschmidt, *Bridge in Frankfurt*, 1923, drypoint.

and fill it with a life of its own reminiscent of Vincent van Gogh. The landscape's natural forms have been arranged into a deliberate pattern. The horizontal wavy lines and circular shapes of the water's eddies and ripples contrast with the straighter and more vertical lines of the background landscape. A similar structuring of reality is observable in the 1923 drypoint *Bridge in Frankfurt* (cat. no. 73). Here, an iron suspension bridge leads the eye into the distance where the skyline of Frankfurt-am-Main can be glimpsed in schematic outline. The sweep of the bridge is echoed by the clouds and contrasted by the city skyline, whose structures are played off against the girders of the bridge. The deep and richly dark lines establish an overall play of line and pattern. The scattered group of individuals on the bridge add an anecdotal detail to the print.

As Kleinschmidt's career progressed, he increasingly began to focus on depictions of women. Such images soon became his trademark and were done in both graphics and oils. Two fine examples are *Fortune Teller* (cat. no. 71) and *Woman at Her Toilet* (cat. no. 74). Despite the brusquely foreshortened perspective in both sheets, the objects are rather realistically

cat. no. 71. Kleinschmidt, *Fortune Teller*, 1922, drypoint.

cat. no. 74. Kleinschmidt, *Woman at Her Toilet*, 1922, drypoint.

93

rendered. It is only when one notices the gigantic size of the women and observes how they have been crammed into the pictorial space that the meaning of the scenes becomes clear. Removed from the realm of the ordinary and the natural, the women are symbols of overripe fecundity, brutal power, and physical ugliness. And in *Woman at Her Toilet*, the blank vacant stare of the woman strikes a note of utter desolation.

Like many other artists in the show, Kleinschmidt also did self-portraits. The *Self-Portrait* of 1922 (cat. no. 72) shows him at work, leaning somewhat to one side in order to get a better view of whatever it is he is drawing (or perhaps etching). Like Meidner and Corinth, Kleinschmidt depicted himself as an artist and craftsman, surrounded by the accouterments of his profession. The sketchily delineated figure is rendered with

cat. no. 72. Kleinschmidt, *Self-Portrait*, 1922, drypoint.

94

cat. no. 76. Campendonk, *Seated Harlequin*, 1922, woodcut.

quick slashes and cuts, but because they are so regularly placed across the page the main impression is one of restraint and control. Coupled with the fixed gaze of the figure, this linear treatment further underscores Kleinschmidt's characterization of himself as an intently self-absorbed artist. The last print that Kleinschmidt did before giving up printmaking in 1930 was also a self-portrait.

Whereas Dix and Kleinschmidt sought to reveal inner truths by looking hard at reality itself, Heinrich Campendonk (1889-1957) created an idyllic, evocative world that is highly subjective. Inspired by his inner experience and personal symbols, Campendonk's graphics stress the instinctive over the intellectual and the unconscious over the rational. Unlike so many of his avant-garde contemporaries, his work lacks any sense of engagement with curent social and political problems.

The three pieces by Campendonk presented here are all woodcuts: *Nude with a Cat* of 1912 (cat. no. 77); *Man with a Flower* of 1918 (cat. no. 78); and *Seated Harlequin* of 1922 (cat. no. 76). In all of them nature, animals, and humans have been assembled into dreamlike, illogical scenes somewhat reminiscent of the works of Marc Chagall. Unlike many artists

exhibited here, who experimented with the woodcut technique, Campendonk employs the medium in traditional ways through the juxtaposition of tonal areas and the creation of a linear surface pattern.

These conventional qualities are beautifully realized in *Man with a Flower* and *Seated Harlequin*. In each one, the areas of black and white have been deftly distributed across the entire piece and within each individual object to produce a totally harmonious balance. Furthermore, the kind and quality of the lines create a fascinating interplay and a rich web of structural patterning.

The piece that deviates from this formula is *Nude with a Cat*. Done in 1912, it is the earliest of the three woodcuts. Here, the values are more tightly bunched together and the linear execution is more angular and harsh. Consequently, it lacks the decorative execution of the other two woodblocks as well as their idyllic, fanciful mood. Instead, *Nude with a Cat* is unsettling and mysterious. This haunting quality is further enhanced by Campendonk's decision to print the work on gray prepared paper. Beyond its stylistic difference from the two companion woodcuts, *Nude with a Cat* provides an excellent opportunity to study the evolution of Campendonk's graphic technique in the 1920s.

cat. no. 78. Campendonk, *Man with a Flower*, 1918, woodcut on japan paper.

cat. no. 77. Campendonk, *Nude with a Cat*, 1912, woodcut on blue-gray paper.

 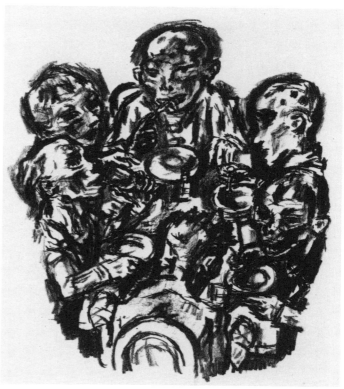

A far more representational approach was adopted by the painter and lithographer René Beeh (1886-1922). Beeh's work is very little known primarily because of his untimely and tragic death at the age of thirty-six. Born in the town of Strasbourg, he received his training at the Academy in Munich. In 1911-1912 he traveled to Algeria. He settled in Munich after the end of World War I but was about to move from Germany to the south of Italy at the time of his death.

Two examples of Beeh's graphics are included in this show; they are both lithographs. *Man Walking with a Little Girl* (cat. no. 83) and *Six Diners at Table* (cat no. 84) were published in 1921 (the year before the artist died) in a portfolio of illustrations to August Strindberg's *Inferno*. Although printed on very large sheets of paper, both images occupy only a small part of the total page. The lithographic strokes are sure and forceful and impart a feeling of power and authority to the images. The schematized shapes were created with an eye toward pattern and linear design. In *Man Walking with a Little Girl* the brushwork is predominantly horizontal and vertical. In *Six Diners at Table* there is a clear preference for circular rhythms. It is especially noticeable in the overall format, in the arrangement of the diners, and in the delineation of the six heads and plates.

cat. no. 83. Beeh, *Man Walking with a Little Girl*, 1921, lithograph (at left).

cat. no. 84. Beeh, *Six Diners at Table*, 1921, lithograph (at right).

cat. no. 87. Gangolf, *Tightrope Walker*, lithograph with hand coloring.

While the work of René Beeh is relatively unknown, the creations of Paul Gangolf (1879-1935?) are even more unfamiliar. An entirely self-taught artist, he worked in a variety of print media (woodcuts, etchings, lithographs, drypoint) in addition to oils and watercolors. Two fine lithographs by Gangolf are included in the exhibition: *Tightrope Walker* (cat. no. 87) and *Street Scene* (cat. no. 86).

In the first of these, the tightrope walker is viewed from an extremely high angle. Below her, the city is flattened out across the page. Because it is difficult to distinguish the woman from the dense mass of the skyline, Gangolf has handcolored the image. The strongest tint—a rosy pink—is applied to the tightrope walker herself. Around it, daubs of pink and yellow sparkle among the buildings while also balancing the predominant hue. At the very top of the sheet flecks of blue can be seen representing the sky beyond. Despite the delightful tonal additions, the risk being run by the tightrope walker is very apparent. Yet the element of danger is a necessary element for

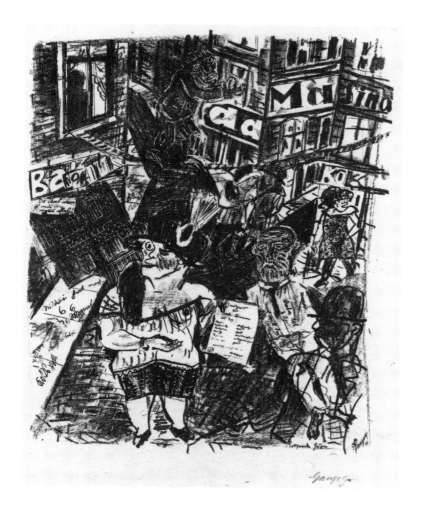

anyone who undertakes such a feat. It could be that Gangolf is expressing an ambivalent attitude toward risktaking as well as toward life in a metropolis.

Street Scene of 1925 depicts an unnamed city and several of its inhabitants. The architectural elements have been placed across the surface in a cubist manner, while the angularity of the buildings and the precipitous thrust of the structures is very expressionistic. Assorted individuals are scattered throughout the print. Some are rather fully realized, while others appear as disembodied ghosts or visual ephemera. Words selectively written on the image are suggestive of graffiti. The grimy atmospheric effect was created through tonal variations of the lithographic ink, which recalls the somewhat similar effects achieved by Nolde in his views of Hamburg harbor (cat. nos. 29 and 30). The jumbled overlay and confusion of shapes aptly characterize the rapidly shifting perspectives, blurred impressions, and dizzying flux of city life.

cat. no. 86. Gangolf, *Street Scene*, 1925, lithograph on japan paper.

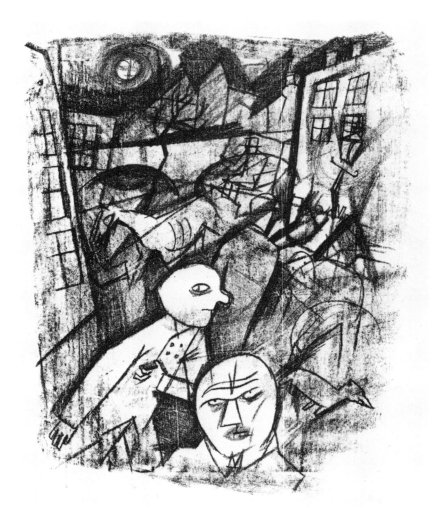

Another interesting depiction of the same subject is *Moon-lit Night* (cat. no. 85) by George Grosz (1893-1959). It was published in 1916 as part of *The First George Grosz Portfolio* by the Malik-Verlag, Berlin. It is a lithograph like Gangolf's *Street Scene*. But Grosz did not draw the image directly onto the lithographic stone. Instead, he first made a drawing on paper with a litho crayon and then transferred the image to the stone. The method can best be understood by comparing the diffused atmospheric tonality in *Moonlit Night* with the more dense effect of *Street Scene*.

This emphasis upon style and purely formal concerns also underlies the 1919 woodcut *Two Nudes* (cat. no. 88) by Eugen Hoffmann (1892-1955). This is only one of the series of prints in which the artist analyzed the human form. In each, the figure was abstracted and reduced, as here, to its basic geometric components. This fascination with volume and mass

cat. no. 85. Grosz, *Moonlit Night*, 1915/1916, lithograph on japan paper.

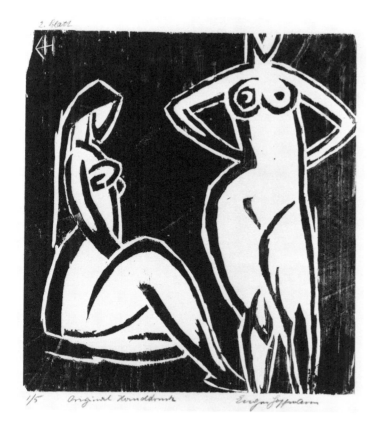

is closely allied to Hoffmann's work as a sculptor. In both media, he sought to uncover the ideal human image through equating it with its architectonic equivalents.

The prints of the artist Rolf Nesch (1893-1975) bring this exhibition full circle. In one way, Nesch is a direct follower of Ernst Ludwig Kirchner, with whom he spent six weeks in 1924; at the same time, his art looks forward to the kind of experimental printmaking that would characterize the decade of the 1950s. Through him, the Expressionist tradition has been handed on to later generations of European and American printmakers after World War II.

Nesch took up graphic arts around 1922. The two examples of his work exhibited here were both created in the late 1920s: *Model* (cat. no. 90) and *On the Shore* (cat. no. 89). *Model* is the more representational of the two. It depicts a close-up view of a woman looking off to her left. The strongest tint is the dark band at her neck (possibly a choker). It is subtly complemented by the shading on the neck, lips, eyes, and under the nose. These hues, in turn, are balanced by the sur-rounding areas of white which, together with their darker counterparts, produce a perfectly graded tonal harmony. The

beads around the woman's neck seem to mediate between the extremes of light and dark. They were created by allowing the acid to bite clear through the plate itself, a revolutionary technique which would be imitated by a later generation of printmakers.

While *Model* relies upon the delicacy of the hues to achieve its effect, *On the Shore* exploits a far more dramatic contrast. The figures of the three standing bathers are summarily defined by the same rich shade of black. Like a halo, a nimbus of white surrounds each of them. The shoreline is an abstracted vertical line of the same hue as the bathers. The water, in contrast, is gray. Indeed, it is of an intensity exactly midway

cat. no. 90. Nesch, *Model*, c. 1926, drypoint and tonal etching with etched holes on japan paper.

cat. no. 89. Nesch, *On the Shore*,
c. 1929, drypoint and tonal etching on
calendered paper.

between the shades of the black and of the white. Furthermore,
whereas the figures are solid entities, the water is rendered
with loose strokes, each line readily discernible. Through these
means, Nesch not only generated an evocative interplay of
tones, but also produced a wonderful sense of textural contrasts.

Like many avant-garde artists Nesch fled Germany during
the early 1930s. His art had been classified as degenerate by
the Nazis. For him, as for many others, the Hitler era was a
period of profound doubt, turmoil and personal anguish. The
most extreme symbol of that anguish was Kirchner's death.
In 1938, unable to endure the accusations heaped upon him
by the Nazi regime, he committed suicide. Yet after World
War II, the younger generations were able to reestablish con-
nections with the country's noble artistic heritage, and the
great flurry of artistic creativity known as German Expres-
sionism continues to give inspiration to artists in Germany
and throughout the world.

cat. no. 10. Kirchner, *Bathing Couple*,
1910, color woodcut on blotting paper.

LIST OF WORKS IN THE EXHIBITION

1 Ernst Ludwig Kirchner,
1880–1938
Reclining Nude, c. 1905
lithograph
Schiefler 16

2 Ernst Ludwig Kirchner
Female Nude, 1908
woodcut on blotting paper
Dube 129 II/II

3 Ernst Ludwig Kirchner
Dancing Couple, 1909
lithograph on yellow paper
Dube 120

4 Ernst Ludwig Kirchner
*Windmill near Burg
on Fehmarn*, 1908
lithograph on japan paper
Dube 54

5 Ernst Ludwig Kirchner
*Street Corner in
Dresden*, 1909
drypoint on blotting paper
Dube 60

6 Ernst Ludwig Kirchner
Russian Dancers, 1909
color lithograph
Dube 130

7 Ernst Ludwig Kirchner
*Bridge on Crown Prince
Embankment*, 1909
drypoint with tonal etching,
on blotting paper
Dube 63 II/II

8 Ernst Ludwig Kirchner
*Naked Girls in the
Studio*, 1911
lithograph
Dube 182

9 Ernst Ludwig Kirchner
Performer Bowing, 1909
color lithograph
Dube 122

10 Ernst Ludwig Kirchner
Bathing Couple, 1910
color woodcut on
blotting paper
Dube 158 II/II

11 Ernst Ludwig Kirchner
Girls from Fehmarn, 1913
woodcut on yellow paper
Dube 219 II/IV

12 Ernst Ludwig Kirchner
Acrobat on a Horse, 1913
drypoint on blotting paper
Dube 165

13 Ernst Ludwig Kirchner
Fanny Wocke, 1916
woodcut on blotting paper
Dube 275

14 Ernst Ludwig Kirchner
Five Tarts, 1914
woodcut on blotting paper
Dube 240 II/II

15 Ernst Ludwig Kirchner
*The Wife of
Professor Goldstein*, 1916
woodcut on blotting paper
Dube 272 II/II

16 Ernst Ludwig Kirchner
*Mountains with a
Mountain Hut*, 1921
woodcut touched with ink
Dube 446 I/III

17 Ernst Ludwig Kirchner
Harmonica Player, 1919
color lithograph on
blotting paper
Dube 341/b

18 Ernst Ludwig Kirchner
*The Blond Painter
Stirner*, 1919
color woodcut on
oriental paper
Dube 406 II/III

19 Ernst Ludwig Kirchner
Mountains, 1920
etching and tonal etching,
touched with ink,
on blotting paper
Dube 348 II/III

20 Ernst Ludwig Kirchner
Pianist and Singer, 1928
woodcut on blue
blotting paper
Dube 598 III/IV

21 Ernst Ludwig Kirchner
*Mary Wigman's
Dance*, 1933
woodcut touched with ink
Dube 639 I/II

22 Ernst Ludwig Kirchner
*Three Bathers by
Stones*, 1913
color lithograph on
calendered paper
Dube 235 I/II

23 Ernst Ludwig Kirchner
*Portrait of a Girl
(L's Daughter)*, 1921
lithograph on rose paper
Dube 408

24 Max Pechstein, 1881–1955
Girl, 1909
drypoint and etching
on tan cardboard
Fechter 40

25 Max Pechstein
Variety Dancer, 1909
color lithograph on
yellow paper
Fechter 72

26 Emil Nolde, 1867–1956
*Man in a Top Hat
(Dr. Gustav Schiefler)*, 1911
lithograph
Schiefler-Mosel 39/II

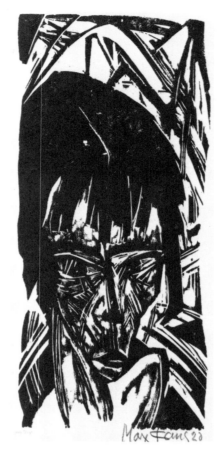

cat. no. 56

27 Emil Nolde
Scribes, 1911
etching and tonal etching
Schiefler-Mosel 154/II

28 Emil Nolde
*Hamburg, Church of
Saint Catherine*, 1910
etching and tonal etching
Schiefler-Mosel 143/II

29 Emil Nolde
Steamer, 1910
etching and tonal etching
Schiefler-Mosel 135/IV

30 Emil Nolde
*Hamburg:
Reihersteigdock*, 1910
etching and tonal etching
Schiefler-Mosel 145/II

31 Emil Nolde
Dancer, 1913
color lithograph with
hand coloring
Schiefler-Mosel 56

32 Karl Schmidt-Rottluff,
1884–1976
*Woman with Unbound
Hair*, 1913
woodcut
Schapire 123

33 Karl Schmidt-Rottluff
Portrait of Guthmann, 1914
woodcut
Schapire 137

34 Karl Schmidt-Rottluff
Sunset on the Quay, 1910
lithograph
Schapire 70

35 Erich Heckel, 1883–1970
Lake in the Park, 1914
drypoint
Dube 122

36 Erich Heckel
Standing Woman, 1911
woodcut with hand coloring
Dube 234/Ia (dated 1912)

37 Erich Heckel
*Two Figures by
the Sea*, 1920
woodcut
Dube 326/B

38 Karl Schmidt-Rottluff
Nude, 1909
woodcut
Schapire 21

39 Otto Mueller, 1874–1930
Girl on a Couch, 1921
lithograph
Karsch 146/IIb

40 Otto Mueller
Two Bathers, 1921–1922
lithograph
Karsch 143

41 Otto Mueller
*Girl Seated between
Large Plants*, 1912
woodcut
Karsch 3/II A

42 Lovis Corinth, 1858–1925
*Self-Portrait in a
Straw Hat*, 1913
drypoint
Schwarz 129 A/B

43 Lovis Corinth
Entombment, 1920/1921
drypoint
Müller 556

44 Lovis Corinth
Self-Portrait, 1918 (?)
drypoint
Schwarz 337

45 Lovis Corinth
The Kiss, 1921
drypoint
Müller 575

46 Lovis Corinth
Henny Porten, 1923
soft ground etching
Müller 677

47 Lovis Corinth
*Death and the
Old Man*, 1920/1921
soft ground etching
Müller 548

48 Bernhard Kretzschmar,
1889–1972
My Wife, 1920
etching and tonal etching

49 Bernhard Kretzschmar
Lunch Hour, 1921
etching with tonal wiping

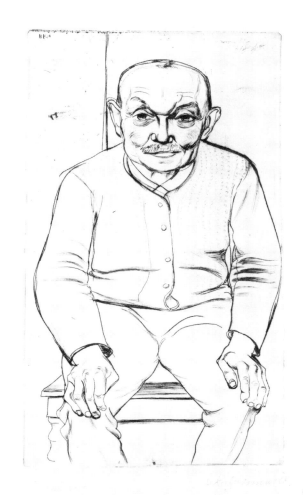

cat. no. 51

50 Bernhard Kretzschmar
Steamers, 1920
etching and tonal etching

51 Bernhard Kretzschmar
Seated Man, 1924
etching and drypoint

52 Ludwig Meidner, 1884–1966
Self-Portrait, 1926
drypoint with tonal wiping

53 Ludwig Meidner
*Self-Portrait in
a Hat*, 1922
etching

54 Ludwig Meidner
*Self-Portrait with
a Needle*, 1919
drypoint

55 Werner Gothein, 1890–1968
Head of a Woman
woodcut

56 Max Kaus, 1891–1977
Head of a Girl, 1920
woodcut

57 Walter Helbig, 1878-1968
Bather, 1914
woodcut

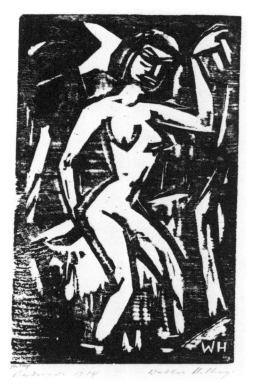

cat. no. 57

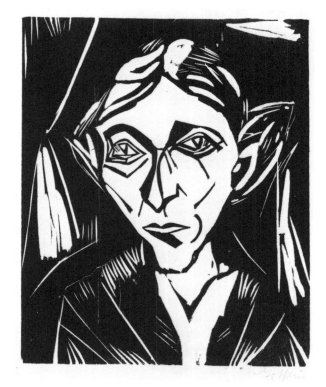

cat. no. 55

58 Walter Gramatté,
1897–1929
Smiling Head
(Self-Portrait), 1923
color etching and abrasion
on japan paper
Eckhardt 156

59 Walter Gramatté
*Three People in a
Cabin*, 1920
drypoint
Eckhardt 142

60 Walter Gramatté
The Couple, 1922
color etching and abrasion
on japan paper
Eckhardt 160

61 Walter Gramatté
The Great Anxiety, 1918
drypoint
Eckhardt 118

62 Walter Gramatté
Weary Soldier, 1919
drypoint
Eckhardt 127

63 Walter Gramatté
Torment, 1920
color lithograph on
blotting paper
Eckhardt 81

64 Walter Gramatté
The Fall into Infinity, 1918
drypoint
Eckhardt 122

65 Walter Gramatté
Burial, 1916
linocut on japan paper
Eckhardt 15

66 Christian Rohlfs, 1849–1938
*The Three Wise
Men*, c. 1910
woodcut
Vogt 22

67 Christian Rohlfs
Walkers, 1921
color woodcut counterproof
on cloth
Vogt 124

68 Christian Rohlfs
*Susanna in the
Bath*, c. 1916/1917
woodcut
Vogt 102

69 Christian Rohlfs
The Prisoner, 1918
woodcut
Vogt 107 II/II

70 Käthe Kollwitz, 1867–1945
The People, 1922/1923
woodcut
Klipstein 183

71 Paul Kleinschmidt,
1883–1949
Fortune Teller, 1922
drypoint

72 Paul Kleinschmidt
Self-Portrait, 1922
drypoint

73 Paul Kleinschmidt
Bridge in Frankfurt, 1923
drypoint

74 Paul Kleinschmidt
Woman at Her Toilet, 1922
drypoint

75 Paul Kleinschmidt
Mountain Rapids, 1924
drypoint

76 Heinrich Campendonk,
1889–1957
Seated Harlequin, 1922
woodcut
Engels 59

77 Heinrich Campendonk
Nude with a Cat, 1912
woodcut on blue-gray paper
Engels 2

78 Heinrich Campendonk
Man with a Flower, 1918
woodcut on japan paper
Engels 58

79 Otto Dix, 1891–1969
*Portrait of Otto
Klemperer*, 1923
lithograph
Karsch 67

80 Otto Dix
Apotheosis, 1919
woodcut
Karsch 30

81 Otto Dix
*Dance of Death
Anno 17*, 1924
etching, aquatint, drypoint,
and burnishing
Karsch 88

82 Otto Dix
*Lady in a Feathered
Hat*, 1923
lithograph
Karsch 62 II/II

83 René Beeh, 1886–1922
*Man Walking with a
Little Girl*, 1921
lithograph

84 René Beeh
Six Diners at Table, 1921
lithograph

85 George Grosz, 1893–1959
Moonlit Night, 1915/1916
lithograph on japan paper
Dückers M1,9

86 Paul Gangolf, 1879–1935(?)
Street Scene, 1925
lithograph on japan paper

87 Paul Gangolf
Tightrope Walker
lithograph with
hand coloring

88 Eugen Hoffmann,
1892–1955
Two Nudes, 1919
woodcut

89 Rolf Nesch, 1893–1975
On the Shore, c. 1929
drypoint and tonal etching
on calendered paper

90 Rolf Nesch
Model, c. 1926
drypoint and tonal etching
with etched holes, on japan
paper